Contents

02
Editorial
Avi Feldman

06
LAW/ART: Constructive Interferences
Sabine Mueller-Mall

14
Law of the State, Truth of Art
Two Case Studies of Art as Evidence
Jonas Staal

24
Proposal for Hungary, 1945
Zoltán Kékesi, Szabolcs KissPál, and Máté Zombory

28
On Michal Heiman's Return:
Asylum (The Dress) 1852–2017

34
Testimony + The Artist as an Expert Witness
Lawrence Abu Hamdan + Text by Avi Feldman

50
An interview with Milo Rau
Conducted by Avi Feldman

54
Along the Law
Hila Cohen-Schneiderman

64
The Sirens' Song: Speech and Space in the Courthouse
Avigdor Feldman

79
Imprint

Cover image:
Marganith Tower, part of the Kirya military compound in Tel Aviv, is situated opposite the Tel-Aviv Museum of art, Beit Ariela Shaar Zion Library, and the Tel Aviv District Court.

Editorial
Avi Feldman

This special issue of *OnCurating* has been conceived with the intention of inquiring into the relation between law and art as it is manifested in a variety of recent artistic and curatorial projects and legal writings. Based on the notion that the law holds an abiding influence on all terrains of society, our aim was to unravel tactics and mechanisms used by art and legal practitioners alike as they deconstruct, reconstruct, and appropriate legal matter and form.

The collection of texts and images assembled together in the journal manifest an exploration of politics and art as it is approached through a legal perception. We aspired to decipher ways in which artists, curators, and legal scholars tackle politics as a sphere in which contested areas are negotiated, leading to administrative ordering and laws. Law encompasses an inherent duality since it is positioned at the intersection of physical force and hegemony, as argued by Antonio Gramsci. This realization was further investigated by Louis Althusser in his writings on ideology, as he identified law as holding an affinity with both the Repressive State Apparatus and the Ideological State Apparatus.

Recognizing the intricacy of positioning law and art in close proximity, as two fields sharing a possible mutual reciprocal relation, this issue of *OnCurating* strives to propose a multilayered reading and interpretation of the law in relation to art. With contributions by legal scholars, artists, and curators, we set out to re-explore their own relation to law and the complexity of administrative and policy making, in an attempt to formulate anew the role law has had and continues to hold in their work, research, and creation. The law's immense power to direct, authorize, and legitimize social relations and institutions is therefore interrogated, underscored, and reflected upon throughout the journal as we trace and map law's evolving definitions, concepts, and practices in contemporary art and legal scholarship.

Sabine Mueller-Mall's opening text directs us into an exploration of the disciplines of law and art through the conceiving of law as a performative, ongoing process. Acknowledging the differing attitudes inherent to the discussion of law and art, Mueller-Mall, who is a legal and constitutional theory scholar, seeks to expose and further establish a certain linkage between seemingly differing spheres. Putting aside assumptions of analogies between the two fields, she argues in favor of allocating spaces of interference that might possibly prove equally productive to both sides. The reciprocal attraction existing between law and art, as noted by Mueller-Mall, can also be related to the duality of law, mentioned earlier, as it was expressed by thinkers such as Althusser with regard to repressive state apparatuses (such as the police, military, state administration, etc.,) and the ideological state apparatuses that confirm (or criticize) an existing state apparatus through addressing its subjects.

Aspiring to form an image of law beyond a normative mechanism for solving conflicts, Mueller-Mall insists on posing the question of what is that "law" to which we so often refer as a given fact. In order to answer this, she brings to the forefront two dimensions of law—performativity and judgment. Mueller-Mall asserts her

claim on recognizing two positions for law—one in books and one in action—and thinking of law as performative connects these two facets together. The inherent tension between the two sides is what constitutes law's performativity, as it captures the concrete while it poses a declaration intended as guiding future interactions.

Thinking about law in terms of performativity suggests a need to re-conceptualize our own relation to law. On this note, Jonas Staal's essay begins with a personal reflection regarding his early encounter with the courtroom and the legal system. What began in 2005 with a series of "memorial installations"—including photos of Geert Wilders, leader of the Dutch ultranationalist Freedom Party (PVV)—resulted in Staal's arrest. Wilders accused Staal of "threatening a Dutch member of parliament with death." Eventually acquitted of all charges, Staal has used the judge's question, "Did you act out of hate against Geert Wilders?," to allow the truth of art to come out as he answered, "No, I consider him my muse." Staal continues to deal with questions of art and law in his ongoing project, the *New World Summit*. Though differing greatly in their motivations and construction, one can say that according to Staal both projects allow the truth of art to emerge "beyond the law of the state."

Since the first New World Summit (2012), which took place in Berlin as part of the 7th Berlin Biennale, four other summits were held in Leiden, Kochi, Brussels, and recently in the autonomous administrative region of Rojava, in northern Syria. The artistic and political organization formed by Staal, along with fifteen other members, was determined from its inception to provide alternative parliaments for a variety of organizations listed as terror organizations. What began as a two-day assembly gathering at the Sophiensaele Theater in Berlin has now amounted to the construction of a new public parliament in the city of Derîk, as Staal brings to fruition his call for politicizing and re-envisioning the state of exception of the arts.

Zoltán Kékesi, Szabolcs KissPal and Máté Zombory's *Proposal for Hungary, 1945* offers yet another approach towards legal administration and the reconstruction of justice. Conceived especially for this issue of *OnCurating*, this team of cultural researcher, artist, and sociologist re-imagine anew the history of Hungary by incorporating the legal mechanism of a Reconciliation Commission. Calling upon a Truth and Reconciliation Commission for Hungary of 1945 in the spirit of the one developed in South Africa, they seek a commission investigating "political crimes committed before 1945. The idea is to replace or complement the model of retributive justice applied in the post-war trials in Hungary (and elsewhere in Europe, most prominently in Nuremberg), with a more restorative model." Their proposal, which they intend to continue to develop and present in other formats and spaces, consists also of a sketch for a new Hungarian national flag, one that pays tribute to the country's diverse nationalities and ethnic groups.

The testimony of artist Lawrence Abu Hamdan further establishes and challenges the contemporary evolving relation between law and art. In much of his recent work, Abu Hamdan investigates the relation between sound, listening, politics, and law, which led to him being called in 2013 to testify before a UK asylum tribunal as an expert witness. Abu Hamdan's expertise was the outcome of a long research process on language analysis for the determination of origin of asylum seekers. The audio documentary *The Freedom of Speech Itself*, which was submitted as evidence to the tribunal, offers an embedded insight into the way forensic speech analysis and voice prints are used to determine the origins and authenticity of asylum seekers' accents.

The invitation of an artist to serve as an expert witness at a tribunal dealing not with art-related issues but with an urgent matter of human rights spurred Avi Feldman (guest editor of this edition of *OnCurating*) to further elaborate in his essay on the shifting concept and position of the expert witness in our time. Intrigued by the role artists and curators might have in the realm of the legal system, Feldman provides us with a short history on the transition in the definition and acceptance of the expert witness in the adversarial legal system. The question of who is an expert witness and what constitutes one has been discussed at length by legal practitioners and scientists throughout the last centuries. With the advancement of technology and science, the courts had to find solutions for how to accept new means of evidence, and with it a new characterization and requirements for the expert witness. It may be that new forms of evidence and witnessing, as in the matter of sound research in the work of Abu Hamdan, will require the courts to once again re-examine their own legal methods and practices as they integrate expertise and knowledge gained by artists and curators.

Now, from a direct artistic involvement in the legal system, curator Hila Cohen-Schneiderman reflects in her essay on her experience as co-curator of an artist's residency conducted in the midst of the legal department of the Jerusalem municipality (May-July 2012). One of the outcomes of this residency was a video created by artist Ruti Sela, who worked, sketched, interviewed, and videotaped the department's lawyers. Titled *For the Record*, Cohen-Schneiderman provides us with a quote from the video in order to demonstrate the perceived rooted differences between the fields of art and law, as Sela declares them to be "almost the opposite. To me, being an artist means wanting to be beyond the law or not to believe that there is a law […]."

Under the subtitle "Trojan Horses", as it appears with a question mark, Cohen-Schneiderman raises questions, concerns, and doubts on her practice as a curator in the framework of the municipality, as she also provides us a closer insight into Sela's intervention at the offices of the legal department. Acknowledging previous related projects, which also operated within state institutions and commercial industries, Cohen-Schneiderman ends her essay with some of her recent conclusions following her latest curated exhibition at the Petach Tikva Museum of Art in Israel. Aiming to create non-hierarchical rules of conduct and exchange among artists and curators, she reflects on the challenges and limitations that artistic and curatorial interventions face when aiming to create change from within.

Milo Rau's project *The Congo Tribunal* demonstrates, through the appropriation of a legal construction, how the global economy has destroyed the lives of millions in the Democratic Republic of Congo. Acting as a tribunal and calling upon dozens of witnesses in Bukavu and in Berlin, the project investigates the responsibility of international companies, the World Bank, NGOs, and the UN of crimes against humanity committed in Congo during the past decades. Interested in theatrical re-enactments, Rau has, prior to the Congo Tribunal, directed two other works that also deal with the legal system: *The Moscow Trials* and *The Zurich Trials*. Emphasizing the significant difference between a trial and the creation of a tribunal, the interview sheds light on the meaning and function of law and of legal formats in contemporary theater and film as it is manifested in the work of Rau.

The concluding essay, perhaps a sort of epilogue, was written by Avidgor Feldman in 1991, and has been translated into the English by Lenn J. Schramm especially for this edition of *OnCurating*. Feldman, an acclaimed lawyer and activist working in Israel, stated in several interviews his disenchantment with the law,

claiming it to be nothing but "a game of lies." In this contemplative article, published in the inaugural issue of the journal *Theory and Criticism* (*Teoria U'vikoret*), Feldman takes us through the Tel Aviv District Court's architecture, as he is "looking for the invisible links between the legal space and the legal text and at their common effort to create a vocabulary, gestures, and rules of conversion and concealment."

Feldman's original text is accompanied by photography created by artist Michal Heiman. For this edition of *OnCurating*, Heiman will be presenting different images from one of her most recent projects titled *Asylum (The Dress) 1852-2017*. Investigating the concept of return–be it of a land, home, time, condition or status–Heiman is provoking us to travel to a time when women were deprived of the most basic rights. She confronts the issue of human rights, and specifically the breach of rights of asylum seekers and refugees, boldly yet enigmatically through a series of portraits, a few of which are now also on permanent display at the Tel Aviv District Court's new wing that opened to the public in 2014.

Avi Feldman, *Guest Editor, (Born in Montréal, Canada) is based in Tel Aviv, Berlin, and Dresden, where he works as a curator and writer. Since 2013, Feldman has been a PhD candidate at The Research Platform for Curatorial and Cross-disciplinary Cultural Studies, Practice-Based Doctoral Programme–a collaboration between the University of Reading (UK) and the Postgraduate Programme in Curating, Zurich University for the Arts (CH). As part of this programme, his thesis focuses on examining contemporary reciprocal relations between the fields of art and law. Feldman's research is supported by ELES - Ernst Ludwig Ehrlich Studienwerk.*

LAW/ART:
Constructive Interferences
Sabine Mueller-Mall

In this article I will reconsider the way we typically think of the relation of law and art from a legal theory perspective, and perhaps this could even lead to a little rerouting of the conventional imagination we attach to law.

I. Law and Art – Attraction or Repulsion?

Many works of art[1] involve legal topics, legal ideas, or legal procedures and practices—recent examples are, for instance, Rimini Protokoll's *Zeugen! Ein Strafkammerspiel*,[2] or Milo Rau's film and theatre productions *Die Moskauer Prozesse*[3] and *The Congo Tribunal*[4]. At the same time, art is not rarely the object of legal cases (e. g. *Mephisto*[5] and *Esra*[6] before the German Constitutional Court)[7], or of legal thought[8]. The reason for a reciprocal appearance of "the other" could be found in a specific attraction as well as in a pronounced repulsion of law and art: is it the "scandal" (more or less) hidden in every legal case that renders legal topics attractive for art? Does the law have particular difficulties dealing with the "as if" which often characterizes the sphere of art? Or alternatively, is art attractive for legal thought because the aesthetic and the juridical have something in common? Or do we have to think the other way round: is it the impossible relation, the impossibility of any relatedness, the conceptual repulsion of law and art that makes confrontations so attractive?

Although law and art have the reputation of belonging to widely different spheres, certain structural peculiarities of law might work as possible catalysts for both: for law's orientation towards art as well as for artworks that include aspects of influencing, challenging, or questioning the law. Examples I shall outline in the next sections are the *performativity* of law and its directedness towards *judgment*. Of course, there are possibly "structural peculiarities of art" that foster the same effects, too—my concentration on a law-oriented perspective is based on a decision (which is caused by the fact that my expertise is limited to this perspective) and not on necessity.

But before delving deeper into that law-oriented perspective, before crystallizing those peculiarities of law that could be vantage points from which we could undertake further experiments of artistic and legal co-working, we should take one step back and have a look at the conventional and familiar picture of the relation of law and art:

"Modern law is born in its separation from aesthetic considerations and the aspirations of literature and art, and a wall is built between the two sides. The relationship between art, literature, and law, between the aesthetic and the normative, is presented as one between pluralism and unity, surface openness and deep closure, figuration and emplotment. Art is assigned to imagination, creativity, and playfulness, law to control, discipline, and sobriety. There can be no greater contrast than that between the open texts and abstract paintings of the modernist tradition and the text of the Obscene Publications Act, The Official Secrets Act, or indeed any other statute."[9]

Often quite solidified in discourse, the relation of law and art is drawn as one of radically distinct spheres. And in fact they are very different in a certain sense: if we think of law and art as institutionalized practices, of course both fields can be identified as different universes, e. g. courts and galleries, could we think of more distant places? A tribunal and an installation–who would dare to think of any similarities? A lawyer and a curator–do these roles share anything at all? At first sight, those questions seem to be rhetorical. Of course there are no similarities, maybe not even thinkable junctions. The relation of art and law, therefore (as is a widespread judgment), has to be limited to hierarchical treatments: legal judgments on art (e.g. on copyrights), or artistic judgments on law. Either law deals with art or art deals with law–but both connections are more treatments than linkages; in this understanding (that I shall challenge in the following sections), the one's dealing with the other has no further implications. If a legal court judges on art, this judgment does not fall back on law itself or the other way round with art on law.

And still, in both spheres, in legal thought and in art, the very different sphere of the "other" is the rage, as mentioned above: the list of publications on law and art, law and the image, etc., is probably slightly smaller than that of artworks dealing with legal material or procedure. And it is not only the great amount of cross over in both directions that attracts my attention, but also the observation that these linkages do not remain without consequences: the above-mentioned works (of art) and (legal) cases do not make the (legal) cases and works (of art) *objects* of the latter (former). I would turn it around and affirm that the relation of art and law in these constellations could be better described by a concept of *reciprocity*. As far as *The Congo Tribunal* makes use of legal procedures, this "making use of law" drops back to the art work–in this particular case (which serves as an example here), the spectators of the play/performance get into a juridical situation: their judgment is not purely aesthetic but also juridical; the question of beauty or "good" art turns into a question of justice or rightness. And the prohibition of the selling of a novel does not only formulate a juridical verdict, but will also cause a special reading of the forbidden novel in the future: it is irreversibly an illegal act to read the novel, then, and of course this legal aspect influences the artistic quality, and so the legal case will become part of the reading act[10] and thus the novel.

In a way, we could state that there is a reciprocal attraction of law and art. Thus, we have to admit at second sight: perhaps the opposition of law and art (and not the question of analogies) is more provisional than it seems to be. Even if we outline the institutional settings, there are some structural similarities to be explored–ones that are in contrast to the conventional attributions to law and art[11]. However–to specify my current project–I do not aim to expose analogies of law and art. Rather, I shall try to develop an idea of law that allows an emphasis on vantage points for the observation and creation of linkages of both spheres. The notion of "linkage" might indicate the more complex relationship of art and law to be developed: the logic of linking presupposes distinct objects of which the relationship has to be characterized by a certain balance of attraction and repulsion, which is stabilized through the linkage again. It prevents the melding of both spheres and at the same time it bridges them.

II. Analogies – Why not actually look for parallelisms?
However, before having a closer look at the law, I would like to say a few words on the question of why I am not looking for analogies of law and art. Especially concerning law and literature, analogizing is a quite common strategy to encompass the relationship. There is an already rather well-established field of

research and experiments called "law and literature"[12] or "law as literature"[13]. Those movements might indicate that the assumption is true that it could be promising to look for structural analogies or parallelisms of law and art. One prominent example of such a structural analogy: both law and literature (art) are dependent on practices of interpretation. In other words, neither law nor art can be perceived without using hermeneutic techniques, at least on a very basic level. I can neither apply nor grasp the meaning of a legal norm text without interpreting it. And the same is true for reading a literary text (or watching a play).

Although such kinds of analogies can be taken as an argument for the assumption that both law and art are not those radically distinct spheres that they seem to be at first sight, I will not try to focus on finding such analogies in order to approximate the relation of law and art. In addition, although it is quite clear that the relation of art and law would be designed in an overly simplified manner if law were described only as a possible object of art or if art were understood as a simple object of law, I am convinced that analogies are not very productive for our enterprise because they take a step in the wrong direction. Analogies show similarities on the one hand, but on the other hand they keep a distance that does not allow us to think of intersection points–*parallel lines do not meet*. Instead, my considerations are based on and, at the same time, trace the assumption that there are intersections of law and art that matter for both. As I would turn it around–it is not a parallelism, but instead it is the difference of law and art that makes interferences in both areas effective. Therefore, I shall not place special emphasis on such analogies, although they might appear from time to time in my following considerations. Nevertheless, I am convinced that the differences of law and art that should instead be the focus are to be found in other places than a conventional picture of law might suggest. But what does this conventional picture of law look like, and in what sense does it have to be adjusted? These are the questions I will now further address in the following sections.

III. Law's Image

Law's image is not the best. Typically we think of law as a set of rules defining political spaces and especially: borders. Thus, law is often seen as a limiting instrument, even if it is also a concept that allows us to think of rights. On the other hand, law is also seen as the field where justice is the most important value. Furthermore, law is the technique that makes democracy possible, because democratic decisions would not be associated with a normative force without the idea of law (which is not necessarily true the other way round). We imagine law as creating the distinction of just/unjust and thus creating (metaphorical) spaces, spheres of justice, and other worlds. And still, we often connect law to bureaucratic procedures, boring people, and courts that feel "un-bound." Law is the main technique of conservative, slow institutionality.

In this picture, the concept of law shares two kinds of very different attributions: that of (good) justice and that of (bad) bureaucracy/institutionality/conservatism. Therefore, we have a twofold picture of law, law's difficult image, as the field searching for justice, but also representing motionless institutions that aggregate power.

iV. The Case of Law

The "case of law" is to be found in the always-to-be-bridged difference of law's image and law's practice. Briefly said: if the image is that of a conservative and sometimes boring technique that is still able to provide justice, then its practice is

that of a discomposing and shockingly open, everlasting attempt to balance norms and normative questions. Of course this equilibration, and this is the specific difficulty of law, only works if law can observe [certain] proprieties: only (the image of) a conservative technique can inspire and safeguard confidence in law's normativity and ability of solving conflicts. The difficult task in challenging or criticizing, in provoking or influencing the law is then: to recognize the object of these involvements. Who and what actually is the law? What do we mean when we talk about "law" besides the simplified image described above?

I shall try to approximate this not exactly simple question by exposing two aspects of law that could be interesting for the present considerations: its performativity and its connection to judgment. These two aspects will urge us, as I believe, to think of law as a practice that necessarily has to interact with other spheres. And, this is what I dare to believe at least, those aspects to be outlined will help us to leave a certain very simplified image behind in the dust: the one of (art as free and) law as bound [14].

Law's performativity
"The" law "is" neither just conservative nor exclusively progressive–law refers to antecedence and at the same time it is positing something for the future. If a court judges a case, and does so by referring to a legal norm, the court usually states: we are applying this legal norm in this specific interpretation to that specific case in the version we assume to be true, and this application is fair/just/equitable/legitimate. This assertion is not describing the world, it is judging *and* providing this assertion representing the judgment with legal normativity, or to be more exact, reclaiming legal normativity for the judgment. This claim refers to existing rules (e.g. a rule that installs the court as a legitimate court; the legal norm to which the judgment refers), thus it has a historical component, but at the same time, as a *claim* for normativity it is referring to the future: a legal future of normative perception the original court cannot control by its judgment. Because whether we can speak of (realized, "existing") legal normativity depends not only on the court and its judgment, but also on the normative perception of this judgment in the future: if no other court, no enforcement officer, no administrative agency perceives this judgment normatively, then it would be difficult to call it "law". An example: if a parliament adopts a law, but no one ever takes it seriously and no one ever even tries to apply this law, is it still a "law"? Probably not.

These examples might hopefully illustrate what I mean by saying law is both conservative and progressive at the same time. Legal normativity (which is the necessary condition to identify any simple assertion with the formulation of a legal rule or of a law) cannot be generated by fulfilling a catalogue of requirements. It presupposes an event that refers to other events of law generation as well as it being normatively perceived by future events of law generation. Thus, it can become part of an infinite process of generating legal norms, a process that we call law. Now it might be comprehensible to state that a very common distinction is not really helpful: that of *law in the books* versus *law in action*.[15] This distinction presupposes that there is a constituting difference of a legal norm that is written in a statute, for example, and the application of such a norm. In the picture I am outlining here, law that is "only" in the books can never be law. But how, then, can we imagine law? Is it not a set of rules that allows us to follow the path of regular/irregular distinction? Wittgenstein's rule-following considerations expose us to, among others, an important insight: that the idea of a static rule that is to be identified with its formulation and with its interpretation is not very convincing. Since *rule following is a practice*[16], applying legal norms has to be a practice, too–even if we

conceive of legal norms as rules. This again implies nothing less than that "applying" a legal norm has an effect on this norm.

My proposal is to think of law in a different way: as *performative*. Thinking law as a performative practice includes the idea of a double-sided law. Performative law means always both–in the books and in action; it is constituted by the tension of both. Legal normativity is the result of a practice that is not completed when a legal norm comes into the world (by parliamentary decision for example). Law presupposes a practice–what should a law be like that is never applied?

Also, as I described above, law requires a performative moment to become law, or, to be more precise, it requires more than one performative moment: law is a performative practice. Law's performativity is not identical with the concept of performance (even if we could probably find performance aspects in a trial for example)–it refers to a concept of performativity that describes a way of forming, of per-forming the world through a certain structure of the use of signs that is always both at the same time a *procedure* and a *connection* of a (historical) sign to a (new) context. The concept of performativity here describes a mode of doing something to the world.[17] Thus, the concept of legal performativity describes the way law interacts with the world.[18]

Law interrupts the way of the world. Therefore, the assumption of law as a purely historically operating technique trying to simply apply something that has already been there before its application and will be there in the same way after its application, this assumption can never be true.

What are the consequences of thinking law as a performative practice? Among others, one main consequence is that criticizing law is more complex than criticizing certain discrete assertions assigned to law, because criticizing a practice that is altering the world in a performative way is not possible by referring only to a locution. On the other hand, influencing the law is manifoldly possible: vantage points could be the situation of a performative act generating or iterating a legal norm–e. g. the institutional context of a court, as well as the hermeneutic history of a certain assertion or in terms of the history of ideas involved; especially interesting for influencing the law could be a subsequent act of perceiving the original moment of performative practice.

If we look at law from this performative perspective, there is one other noticeable aspect that brings us to a further vantage point for investigating the relation of art and law: the question of *form and substance*, which will allow us to take a look at the concept of judgment.

Law and judgment
We could be sorely tempted to deny that there is a question of form and substance in law or with law at all. Is it not quite obvious that legal procedure, the *formality* of law, is representing form while the contents of the law are representing substance? As already insinuated in describing the law as a performative practice, the relation is more complicated, or at least, has a more intriguing side: if we comprehend "justice" as I indicated above, as a predicate marking a successive relation-building of a legal norm in a specific interpretation and a specific case, then the use of *justice* differs from a purely material idea. The question of legality becomes a question of "matching".[19] Making a legal judgment, then, means ad-*justing* legal norms and the legal case. The ad-*justing* procedure, now, comprises both

form and substance, but is not to be reduced to one of the two; there is no possibility of describing the procedure of making a legal judgment as purely formal, e.g. by an algorithm. And there is no possibility of giving a general rule of how to apply a legal rule to all thinkable cases, in other words, we cannot give a definite answer on the question of which cases exactly are contained in a rule.[20] Recognizing that legal judgment is still possible, we have to admit that it necessarily has to have a creative quality that can at least bridge procedure and material. A legal judgment, thus, is a pure judgment, thinking a "general" and a "specific" together.[21] This thinking "together" cannot be completely described by the concept of "subsuming"–by subsuming a case to a rule–because a court has to find the general norm that (Wittgenstein!) *matches* with the case. And this finding process is hermeneutic as well as creative–it requires finding a matching legal norm to a case as well as interpreting this norm, adjusting it so that the matching becomes obvious. This procedure of perceiving a specific case and a general norm and adjusting both until they match is probably best grasped as a reflective judgment. This again is the kind of judgment Kant described along the example of an aesthetic judgment.

I am not indicating that legal and aesthetic judgments are identical or very similar, but instead that they could be understood as being members of the same family of judgments. And maybe this is one of the reasons why law and art have some respective attraction for each other: the versions of judgment in law and art are at least as close that they allow to make visible processes of judgment at all—by illustrating one kind of judgment, they refer to the other kind of judgment involved. If, for example, in a play at the theatre, we are forced to make a legal judgment, this confronts us with the role we have as spectators watching the play (artwork) at the same time. Legal and aesthetic judgments are able to refer to each other as practices. Judging an artwork as "good" or "beautiful" reminds us of judging something as "just" or "unjust".

Therefore, not only does the hermeneutic precondition of every legal judgment show a proximity to aesthetic judgment, but also its predication as just/unjust. In other words: the whole concept of "justice" contains similar difficulties as that of "beauty". There is no general rule to be applied concerning these concepts; we cannot define criteria of justice and beauty. Rather, those concepts designate a relation of matching. This relation is always to be established or produced again, in every single legal case and concerning every artwork. We can neither re-apply nor copy it. This singularity is shared by legal as well as aesthetic judgments. It might open a perspective on the relation of both: art and law are not merely modes of interacting with the world. They are, and at this point it is possible to compare art and law, they are modes of interaction with the world that are not necessarily only, but also *directed* towards, judgment. It means in effect that if we want to influence law artistically, this directedness towards judgment could be a weak point because every judgment is not only singular but also fragile; it is subjective and amenable to external influence.

V. Art on Law
Law's performativity and law's directedness towards judgment are only two examples of vantage points that might illustrate how we can approximate a relation of law and art. This relation has a quite abstract character on the one hand, but on the other hand it could liberate the way art imagines the law and thus have a rather concrete consequence: that being that law is not a story from a different planet, but to the contrary, in a way artists are experts of law. This is the case because they

are (possibly) experts of performative acts as well as of dealing with future judgments.

On a more general level, if we understand law as practice, the direct consequence is that law has to interact with other spheres, that there is no exclusive law. Because there is no practice without history, without context, and without future. Law is reacting to questions that are asked by the world, law is interrupting the world, and law is a sequel of the world.

The possibility of art on law, then, is not necessarily connected to a relation that makes law the object of art. Art can spin itself into law by becoming a protagonist of law, by becoming an involved party, by re-enacting (or: enacting?) law (or a part?), by demonstrating the difficult process of law-finding and law-making to the law. In addition, if law is not an unswayable sphere, if law as a judgment-based practice is context-sensitive, art on law will always make a difference.

Notes

1 "Art" is broadly understood here, and includes theatre, literature, performance, and not only visual arts.

2 cf. http://www.rimini-protokoll.de/website/en/project_172.html.

3 cf. http://international-institute.de/?p=89 and http://www.the-moscow-trials.com.

4 cf. http://www.the-congo-tribunal.com.

5 "Mephisto", German Constitutional Court, Order of 24 February 1971 – 1 BvR 435/68.

6 "Esra", German Constitutional Court, Order of 13 June 2007 - 1 BvR 1783/05.

7 See for the case of Russia Sandra Frimmel, *Kunsturteile. Gerichtsprozesse gegen Kunst, Künstler und Kuratoren in Russland nach der Perestroika*, Wien/Köln/Weimar, 2015.

8 See, for example, Dennis E. Curtis and Judith Resnik, "Images of Justice," *Yale Law Journal* 96, 1987, pp. 1727-1772; Curtis and Resnik, *Representing Justice. Invention, Controversy, and Rights in City-States and Democratic Courtrooms*, New Haven, 2011; Oren Ben-Dor (ed.), *Law and Art. Justice, Ethics and Aesthetics*, New York, 2011.

9 Costas Douzinas and Lynda Nead, "Law and Aesthetics," in Douzinas and Nead (eds.), *Law and the Image: The Authority of Art and the Aesthetics of Law*, Chicago, 1999, p. 3.

10 See Wolfgang Iser, *The Act of Reading: A Theory of Aesthetic Response*, Baltimore, 1980.

11 I shall not delve deeper into this aspect; see, for example, Cornelia Vismann, *Medien der Rechtsprechung*, Frankfurt am Main, 2011.

12 See, for example, Richard Posner, *Law and Literature*, Cambridge MA, 2009.

13 See, for example, Sanford Levinson, "Law as Literature", *Texas Law Review* 60/3, 1982, pp. 373–403.

14 Of course, both sides of the opposition have been contested and have had different appearances in different times. For example, a movement called "legal realism" (in the U.S. and in Scandinavia) and "Freirechtsschule" (in Germany) contests the possibility of law being a *binding* normative force; Oliver W. Holmes, "The Path of the Law", *Harvard Law Review* 10, 1897, pp. 457–478; Hermann Kantorowicz, *Der Kampf um die Rechtswissenschaft* (new ed. by Karlheinz Muscheler), Baden-Baden, 2002 (orig. 1906).

15 See Roscoe Pound, "Law in Books and Law in Action," *American Law Review* 44, 1910, pp. 12-36.

16 Wittgenstein, *PI*, § 202.

17 See especially the works of *Austin* who introduced this concept: J.L. Austin, *How to do Things with Words*, Harvard UP, Cambridge MA, 1975; and J.L. Austin, "Performative Utterances" in J.L. Austin, *Philosophical Papers*, Oxford UP, Oxford, 1979, pp. 233-253.

18 For a detailed argumentation, see Sabine Mueller-Mall, *Performative Rechtserzeugung*, Velbrück, Weilerswist, 2012.

19 cf. also Ludwig Wittgenstein, *Lectures and Conversations on Aesthetics, Psychology and Religious Belief*, ed. by Cyril Barrett, Berkeley/Los Angeles, 1967, section III, No. 5: "We are again and again using this simile of something clicking or fitting, when really there is nothing that clicks or that fits anything."

20 This is the case because of the conventional problem of an infinite regress of the application of rules: there is no general rule that defines whether a rule is applicable in a specific case or not. See Wittgenstein, *PI*, §§ 198, 201.

21 cf. Immanuel Kant, *Critique of the Power of Judgment*, ed. Paul Guyer, translated by Paul Guyer and Eric Mathews, Cambridge University Press, Cambridge/New York, 2000.

Sabine Mueller-Mall *is a Professor of Legal and Constitutional Theory at the Department of Political Science of the Technical University Dresden. She has also worked as a Post doc at the Collaborative Research Centre 626: Aesthetic Experience and the Dissolution of Artistic Limits/Free University and at Humboldt University/Berlin. Her main research interests include legal and constitutional theory, globalization of law, theory of judgement, law and aesthetics, and the concept of normativity. Recent publications: Performative Rechtserzeugung (2012); Legal Spaces. Towards a Topological Thinking of Law (2013).*

Law of the State, Truth of Art
Two Case Studies of Art as Evidence
Jonas Staal

The Geert Wilders Works (2005–2008)
The first time I stood in front of a judge was in 2007, when Geert Wilders, leader of the Dutch ultranationalist Freedom Party (PVV), filed charges against me for "threatening a Dutch member of parliament with death."

In 2005 I had made my first artwork: a series of installations and displays, including photos of Wilders, tacked upon trees, surrounded by candles, teddy bears, and white flowers. Over the course of several weeks I had anonymously realized over twenty of those works in the cities of Rotterdam and The Hague. At the time, I considered anonymity a precondition for challenging the function of art outside the framework of a gallery or museum.

Nowadays, Wilders is a notorious politician, well known even outside of the Netherlands, but at the time, his rise had only just begun. At first, the manifestation of the populist right seemed to have found a sudden end when politician Pim Fortuyn was murdered by an animal rights activist in 2001. But in 2004, filmmaker and polemicist Theo van Gogh was killed by a self-proclaimed Islamic radical, Mohammed Bouyeri, member of what the Dutch state considered the terrorist "Hofstad Group." Van Gogh had collaborated with liberal-conservative MP Ayaan Hirsi Ali on a film pamphlet entitled *Submission* (2004) criticizing the "subjected" role of women within Islam. Bouyeri had wanted to kill Hirsi Ali, but she was already permanently surrounded by bodyguards. Van Gogh, however, had refused that kind of protection. He considered himself the "village fool," and was convinced that no one would care to kill the joker of Dutch society. Bouyeri thought otherwise, and used the body of Van Gogh to assault Hirsi Ali's. Bouyeri shot Van Gogh as he was driving on his bike through Amsterdam and subsequently stabbed a letter to Hirsi Ali on his body with a knife.

The history of ultranationalism in the Netherlands moves from one dead body to another. The slain body of Fortuyn in 2001 related to that of Van Gogh in 2004. Van Gogh had been a friend of Fortuyn, and Fortuyn had asked him to become a minister of culture in his future government. Van Gogh, in his turn, was friends with Hirsi Ali, who sided with Geert Wilders in the same liberal-conservative party. The death of Van Gogh radicalized Wilders and made him leave his party in order to establish his own Freedom Party, which took an extremist stance against what he termed the "Islamization of society." For him the dead body of Fortuyn, referring to Van Gogh's, symbolized a substantial and constant threat to the European values, which he considered to be rooted in Judeo-Christian and humanist

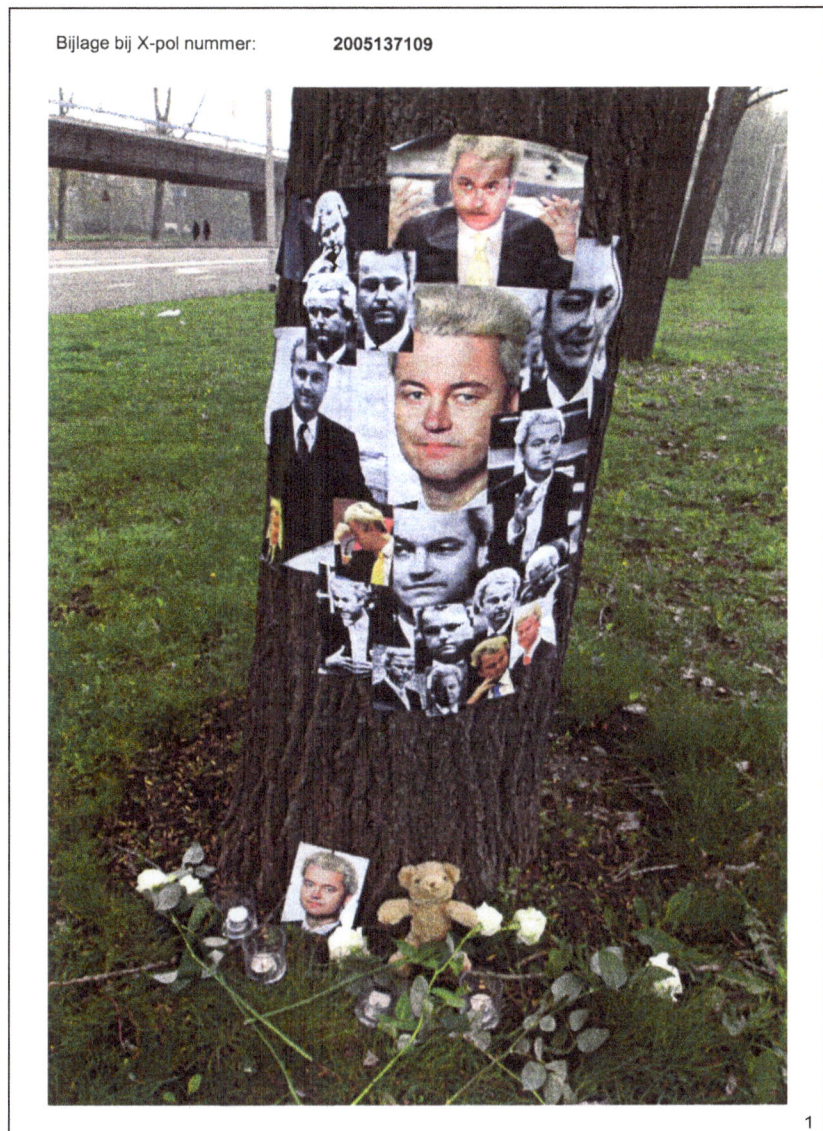

1

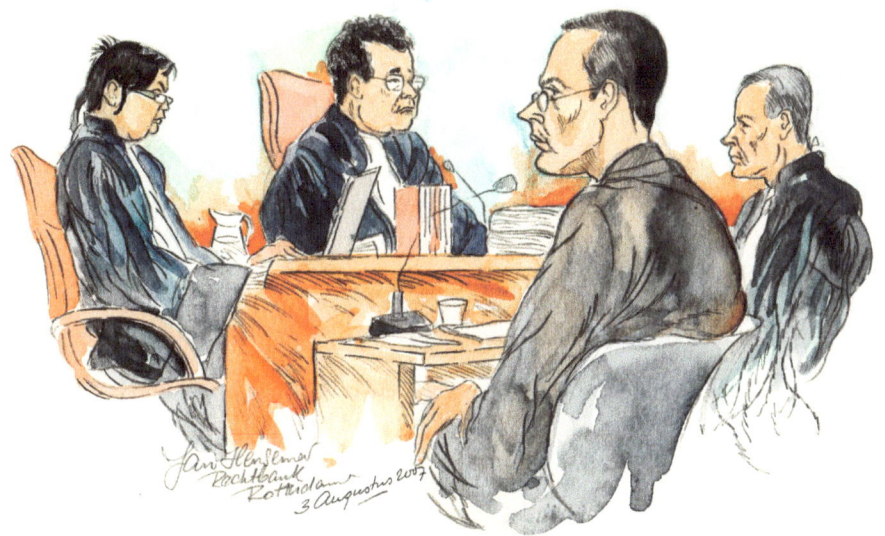

2

culture. The "barbaric" assault on fortress Europe by cells of Muslims (while noting that Fortuyn, despite his strong stance against Muslims, had actually not been killed by one) in the guise of average citizens, needed to be stopped, resulting in a series of proposals by his party ranging from a ban on the building of mosques, the prohibition of the Quran just like Hitler's *Mein Kampf*, banning headscarves from public transport, creating a Guantánamo Bay-modeled prison in the Netherlands and pre-emptively bombing Iran. As a result of these proposals, the threats previously made to the body of Van Gogh transposed to Wilders': from 2004 onward, the politician reported receiving daily death threats and has worked under twenty-four-hour bodyguard protection ever since.

In essence, the politics of Wilders is based on the externalization of an individual threat. Because Wilders feels threatened, he proclaims himself to be the evidence of a threat that concerns the whole of society; the entire European continent even. Because he speaks up for what he considers to be enlightened values and is faced with potential murder, so is the rest of society. Here, the personal becomes political in the most reactionary way possible. The body of an individual is totalized into a collective one: a collective that can only experience this threat through the body of their political leader, not through their own.

Wilders lets no occasion go by without referring to the bodies of Fortuyn and Van Gogh in relation to his own threatened body, and even in live television debates, when he is criticized by oppositional voices, he refers to his bulletproof suit: his body is threatened, and that of the opposition is not. That means that Wilders embodies the truth of the potential decay of Western society, whereas his opponents are merely living a privileged and fragile freedom for which he himself is sacrificed (and not once, but permanently, because he never actually dies). If they dared to see the truth of Islamization, Wilders reasons, then they, too, would turn into bodies evidencing the truth that has been already incarnated into his own: the truth of being a living dead.

As a result, Dutch newspapers by now openly speculate on Wilders' future death. In essence, his message has become common sense: everyone already considers him a dead man, they just await the moment of its official announcement. But the difficulty of the living martyr Wilders is that he does not actually die, he just keeps on living. This turns him into a zombie-like presence: the one we expect to die but never does, thus becoming a terrifying and haunting figure of our political realm.

My memorial installations in 2005 were an attempt to institute that terrible truth through a work of art. While Wilders saw my installations as memorials that *wished him dead*, I intended them as installations that represent the fact that Wilders *never actually dies*. My truth was that of the living martyr Wilders; Wilders' truth was that of a left-wing artist that wanted him dead. As a result, he filed a police report against every single one of my installations as a threat to his life, and when I announced the works to be mine, I was immediately arrested.

So here we are dealing with a clash of two truths: the truth of politics versus the truth of art. Then, third, the truth of the law entered into this confrontation, one that took the form of several hundreds of pages of files developed by the Rotterdam and The Hague municipal police based on their investigation of my artworks. Each of my memorial installations had been photographed by a policeman, each flower had been archived, each photo of Wilders, each teddy bear, each candle conserved. My house had been raided by detectives, where even more teddy bears and photos of the politician in question had been found. Statements of Wilders were included in the file as well as statements by the police investigators of my work, which proved unsure whether the person in question had made the memori-

als in *adoration* of Wilders or as a *threat* to him. So this third reality, the legal reality, manifested itself as an ambiguous composed body of documents, statements, and images. It formed the basis for the confrontation between the truth of art and the truth of politics within the arena of the court. A legal reality that, as should be noted, is not evoked by the artist, but by the political actor (and rarely the other way around).

For me, it was clear that if there were an actual work of art at play here, it was not my memorial installations in The Hague and Rotterdam, but rather the very performative and theatrical structure of the trial itself. I sent out invitations that consisted of the police file—the introduction to the case—as well as a description of the actors that would be central to the event of the trial: the artist, the lawyer, the prosecutor, the three judges. In 2007, when the court case finally took place, this resulted in a bizarre combination of friends, colleagues, art world professionals, journalists, and pro-Wilders supporters as the public to this performance. In the courtroom there was a court artist that I had hired to document the trial, as I was not allowed to photograph or videotape the proceedings. I needed *another artist* to document my artwork; the artwork in the form of the trial itself, the space in which truths clash and reality is contested, altered, reinstituted (and, perversely, one might argue that it was Wilders himself who co-instituted the trial-as-artwork). The court-drawer in question had also documented the cases against the Hofstad Group; the organization of which Bouyeri, the murderer of Van Gogh, had been a member. My own lawyer was J.P. Plasman, who had defended Bouyeri at the time. The actors were in place, just as they had been before, from one dead body to the next, up until the moment that the body of the living martyr (the politician) clashed with the one portraying him (the artist).

"Did you act out of hate against Geert Wilders?" the first judge asked me. "No" I answered, "I consider him my muse."

Silence entered the courtroom. The truth of art played out. The obvious opposition between the ultranationalist politician and the left-wing artist got interrupted. For my work might be considered as threatening—just as I find the very figure of the living martyr threatening—but its intention, the declared proximity to its subject implied in the term "muse," did not fit the logical, causal relation between someone who sends and someone who receives a bullet by mail, which is relatively unambiguously coded as a "hateful" gesture. Moreover, according to the popular imagery, the muse is always a woman, not a man. In other words, a dimension of *intimacy* was introduced between Wilders and me. An intimacy that on one hand re-established me as an actual *artist* (only artists have muses), but on the other hand increased the sense of uncanniness surrounding my actions: the muse-subject cannot disconnect from the obsessed creator. A journalist at the end of the trial thus concluded:

> When asked about his motivations, the artist repeatedly stated that he considered Wilders his muse. This means that this trial might be over for now, but that Wilders is far from liberated from the artist in question.

I was acquitted of all charges in 2008. Wilders was and remains a living martyr haunting the realm of mediation: how do we tell the story of those that never were truly alive and never died either? The truth of politics is one of permanent representation, while the law of the state is presumed to be an empirical one. Yet there is no possible *evidence* to prove the existence of the living dead: only the truth of art provides for the tools to institute such a new reality.

New World Summit (2012-ongoing)

Today, in the context of the War on Terror, we are faced by a *terror instituted by the law* itself. The 2003 invasion of Iraq, causing more than half a million of civilian deaths, was justified as a pre-emptive strike against terror—as a strike against those which would otherwise *escape* the law. This argument allowed for the "empirical" rationale of one of the greatest dangers of our time: global state terror.

When the word terrorism is used, we refer to that which the law cannot contain. The War on Terror operates as a body legalizing state terror on a geopolitical scale in a hysteric response to that which escapes its truth. As a response, the instruments of the War on Terror are employed to render this fundamental opposition stateless. International lists of terrorist organizations, for example, are meant to isolate oppositional forces from the political realm. One's passport is taken away, a travel ban is imposed and bank accounts are frozen, essentially placing a person or organization "outside" of democracy; outside of the state; outside of the law. The terrorist represents that which cannot be encoded in the realm of legal democracy; being one implies a revolt, an insurgency, against its very internal structures. Democracy's law, exported in decades of colonization and imperialist politics, is

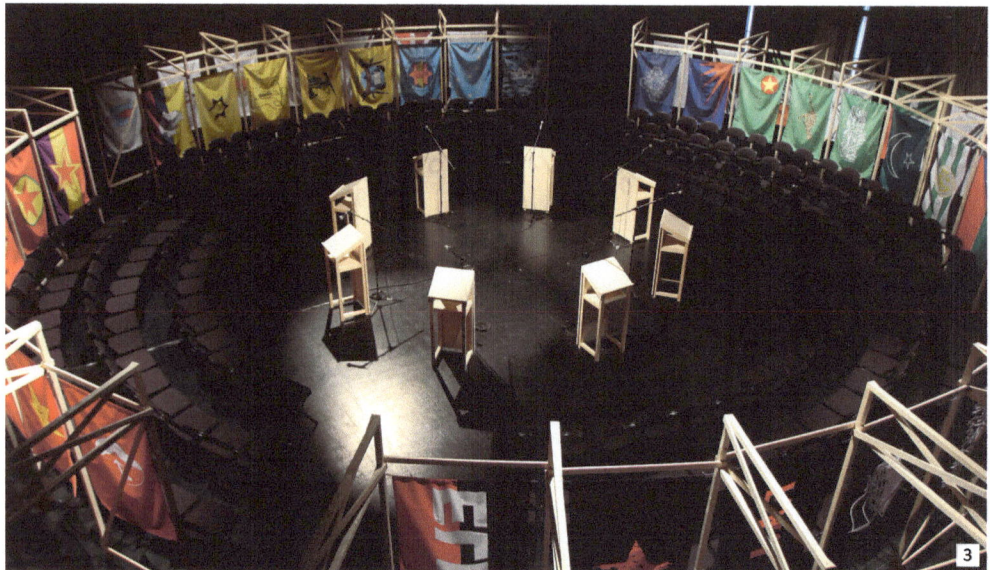

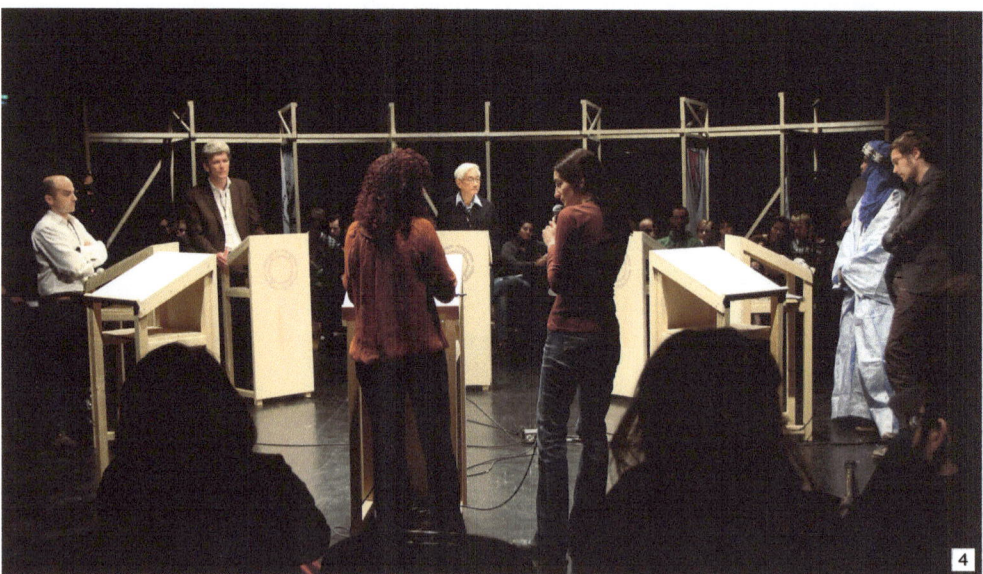

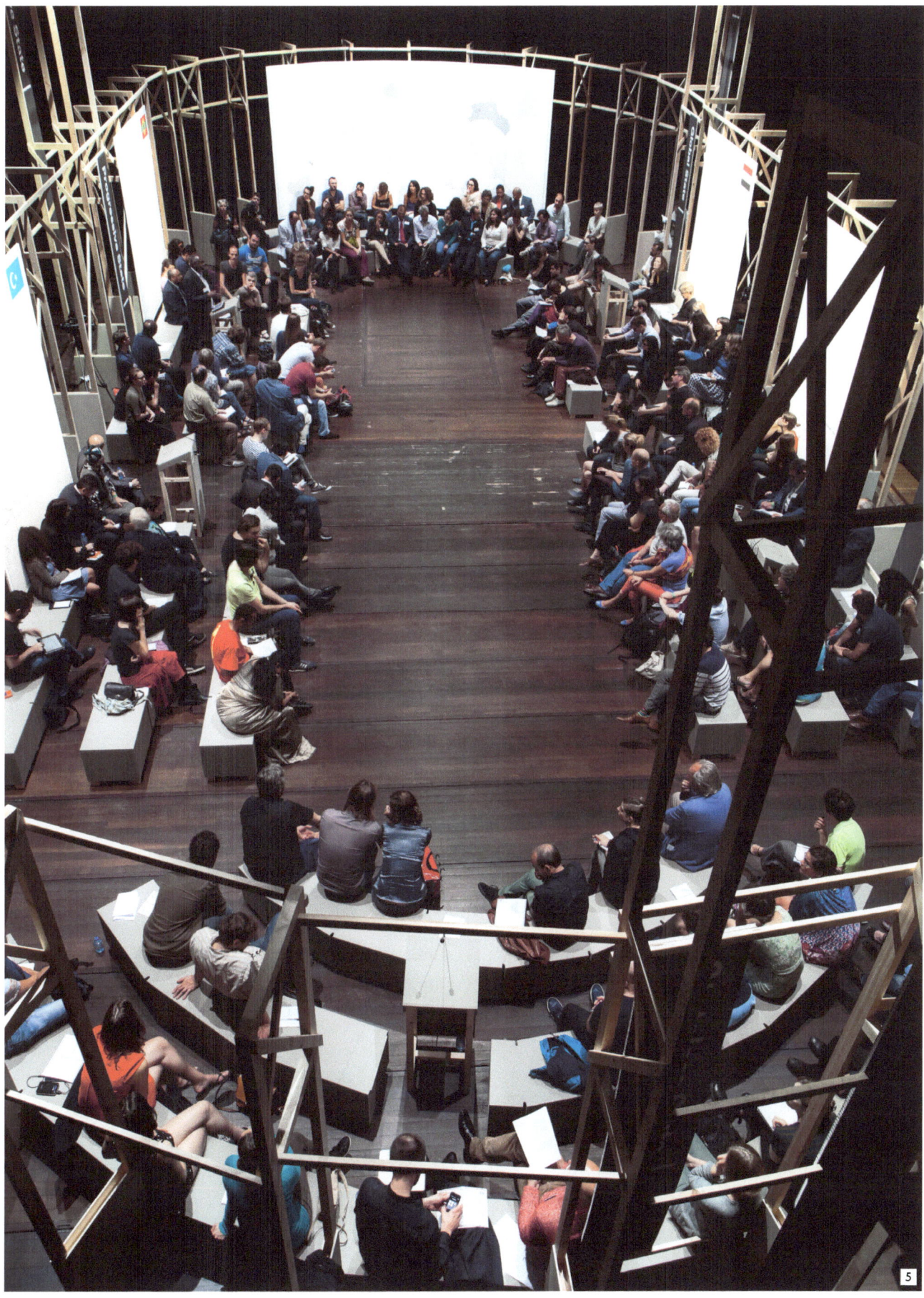

recognized as part of a politics of coercion. Its human rights are the rights of an oppressor, of the documented, of those coded within a legal, administrative sphere of governance. The ungovernable are the stateless, or those who, through the use of terrorist blacklists, have to be declared as such.

In the age of the War on Terror, the body of the terrorist is essentially a form of *evidence* that the law of the state needs to reject in order to maintain its hegemony. It embodies a truth that its structures cannot contain. It is a truth that relates to the past, when it concerns those who are rooted in histories of anti-colonial resistance and liberation movements, ranging from revolutionary movements in the Philippines, Kurdistan, or Tamil Eelam. Or, in many cases, it embodies a truth of former state interests: the American proxy wars waged through jihadist organizations today known as Al-Qa'ida or the Islamic State. Terrorism, although rooted in conflicting histories—the Kurds currently fighting their courageous battle against the Islamic State is one of many examples—is a word with which the state fights its own guilty consciousness. The ones waving their black flags today have bank accounts filled with American oil-dollars and their fingers rest on triggers of weapons manufactured by Empire itself. To declare them terrorist, to bomb them, to forget them by destroying the very evidence of their bodies, is part of a revisionist operation that aims at continuously rewriting history. Proxy armies gone rogue are, for a substantial part, the product of deep state politics; and in order to erase the memory of its own mistakes, a *deep history* is needed: a history continuously rewriting itself in the present through drone warfare and pre-emptive strikes against the bodies that would demand of us to *remember*; remember that the law of the state, under the name of democracy and human rights, bred its own monsters, which it fights again today.

What is called terrorism in the form of non-state actors is essentially an ongoing *trial* against this very history of state terror. But it is a *trial without a space to perform itself*. It is a trial without a court, without its own parliament. When in 2012 I founded the artistic and political organization *New World Summit*, the stated goal of this organization was to establish exactly such a space: a space where the other side of the "justice" of the War on Terror waged in our name could manifest itself, contest, articulate its historiographies, and begin to dismantle, to decolonize the structures of our politics of exclusion. To dismantle the law of the state that today enforces the "limits of democracy," and to establish, through the exceptional space that is art, a space and practice of emancipatory, limitless democracy.

The *New World Summit* has come to exist as a fifteen-member group, whose first members came from the fields of art, design, architecture, diplomacy, and philosophy. To establish our organization, we occupied for two days the space of the Sophiensaele Theater in Berlin where we created our first "alternative parliament": a circular architectural construction, doubling the space of the conventional parliament to allow for shifting relations between speaker and public. Surrounding the parliament were flags of organizations blacklisted in the War on Terror, organized by color: an abstract color prism that revealed its aesthetic and pictorial specificity only upon closer approach. It was a space we constructed in order to establish a different "state of exception" than the one shaped by the War on Terror, which is essentially nothing but the imposition of martial law. Our state of exception, on the other hand, is the *state of exception of art itself*. Not a state in terms of a governmental structure, but a state in terms of an existential condition; and a space exceptional due to its very ambiguity in the domain of the law; as I discussed in regard to *The Geert Wilders Works*.

The ambiguity of art in the space of the law is a direct consequence of the ambiguity that resides in the very notion of art, for art is that which questions its own conditions of presence while being present at the same time. The truth of Wilders, that he is dead and alive at the very same time, is a truth of radical ambiguity that touches exactly on art's state of exception. This does not mean that art cannot be forced into the law, for example by pressure of authorities, threats, or sheer violence. When attempting to mount the third *New World Summit* in Kochi, India, for example, three members of my organization were charged with giving "material support to terrorist organizations." But this material reality in which the *artist* operates does not necessarily undermine the ambiguity that lies in the fact that a parliament–an artwork–meant to be used to construct speech and evidence by political groups dealing with political exclusion through blacklisting is *itself blacklisted*. The blacklisted parliament, in and of itself, evokes images of groups that would in a later stage contribute to the *New World Summit*, such as the Provisional Government of West Papua in exile, which, in its turn, is a *blacklisted government.*

In our first parliament in Berlin appeared Louie Jalandoni of the revolutionary Maoist National Democratic Front of the Philippines; Jon Andoni Lekue, of the Basque Independence Movement; Moussa Ag Assarid of the National Liberation Movement of Azawad in northern Mali, and Fadile Yıldırım of the Kurdish Women's Movement in North and West Kurdistan: all groups that domestically or internationally have been confronted with the politics of blacklisting. All groups with a liberational, anti-colonial heritage, as well as long standing histories in developing alternative models of popular democratic (self-governance). What these speakers bring to the court of the *New World Summit* is essentially a charge against the ruling conception of democracy as such in the age of State Terror. What is on trial are fundamentally competing models of *justice*: between a democracy maintained in the sphere of State Terror, which has to exclude fundamentally contesting voices in order to enforce its legitimacy, and democratic practices *too democratic* to be encoded within the latter. What is on trial is essentially the very possibility of democracy, the possibility of genuine difference and political transformation.

The state of exception of art is one we need to politicize as a space which we can attempt not just to reflect upon, but in which we can *alter* the very mechanisms through which we define and enact representation.

*

In 2007, the goal of the public prosecutor was to bring me to trial. What I brought to trial was a representation of politics as such; a truth in the form of a living martyr yet un-coded within the law of the state. The evidence of this truth was established through an artwork.

The *New World Summit* attempts to bring the *law itself* to trial as an instrument of state terror. An artwork provided the missing courtroom needed for the accusation and the missing parliament where this accusation translates to concrete, competing practices of democracy and justice. The evidence came in the form of those un-coded within the law of the state, as they reject its very premise all together.

As such, beyond the law of the state, the truth of art emerges.

This essay is the result of different conversations on the relation between art and law. Amongst others with Avi Feldman, in relation to his exhibition "Imagine Law" at FKSE Galeria, Budapest (2012); with co-founder of the Center for Terrorism and Counter-Terrorism in the Netherlands, Beatrice de Graaf, who in preparation of the 2nd New World Summit in Leiden (2012) proposed the notion of the "terrorist" trial as one of "competing notions of justice"; with curator Andrea Liu during her conference "Counter hegemony: Think Laboratory" at CAC in Vilnius (2014); and finally with curator Vivian Ziherl in preparation of our lecture "Happy Separatist: Mutant Feminism" during the conference "Muse, powerful totem or harmless object"? at the Frans Hals Museum in Haarlem (2015), where I was able for the first time to expand the notion of the living martyr Geert Wilders as a "muse." The title was first used for a lecture as part of the program "Phantasm and Politics #10: The Right of Art" at the HAU Theatre in Berlin (2015).

Captions
1 *The Geert Wilders Works 2005–2008*, 2005–2008, Jonas Staal, Image: Drawing by court artist Jan Hensema Description: From left to right Officer of justice D. Van der Heem, Judge M. van Boven, suspect J. Staal and suspect's lawyer R. van den Boogert
2 *The Geert Wilders Works*, 2005-2008, Jonas Staal, Photo: Police photograph, OPS file number 2005137109
3 *New World Summit - Berlin*, 2012, Jonas Staal, Photo: Lidia Rossner. Description: The alternative parliament of the New World Summit in Sophiensaele, Berlin, DE, surrounded by flags of organizations faced with blacklisting
4 *New World Summit - Berlin*, 2012, Jonas Staal Photo: Lidia Rossner. Description: From left to right Jon Andoni Lekue (Basque Independence Movement), chairman Robert Kluijver, Fadile Yildirim (Kurdish Women's Movement), Louie Jalandoni (National Democratic Front of the Philippines), translator Meral Cicek, Moussa Ag Assarid (National Liberation of Azawad) and translator Ernst van den Hemel
5 *New World Summit - Brussels*, 2014, Jonas Staal Photo: Ernie Buts. Description:Adem Uzun, representative of the Kurdish National Congress (KNK) who presents his lecture "From Terrorist Organization to Freedom Fighters: The Geopolitical Turn on the PKK"
6 *New World Summit - Brussels*, 2014, Jonas Staal, Photo: Ernie Buts Description: Moussa Ag Assarid, writer and representative of the National Liberation. Movement of Azawad (MNLA) on the left debates his lecture "Revolution without Frontiers: The 21st Century will be that of Peoples, not of States" with Shigut Geleta of the Oromo Liberation Front (OLF)
7 *New World Summit - Brussels*, 2014, Jonas Staal Photo: Ernie Buts Description: Overview of the parliament of the 4th New World Summit in the Royal Flemish Theater (KVS), showing several large scale maps of unacknowledged states participating in the summit

Jonas Staal (born 1981, lives and works in Rotterdam, NL) has studied monumental art in Enschede NL, and in Boston, USA. He is currently working on his PhD research project entitled "Art and Propaganda in the 21st Century" at the PhD Arts program of the University of Leiden, the Netherlands. Staal is the founder of the artistic and political organization **New World Summit** that develops alternative parliaments for stateless organizations banned from democratic discourse, and together with BAK, basis voor actuele kunst, Utrecht, of the **New World Academy**, that connects stateless political organizations to artists and students.

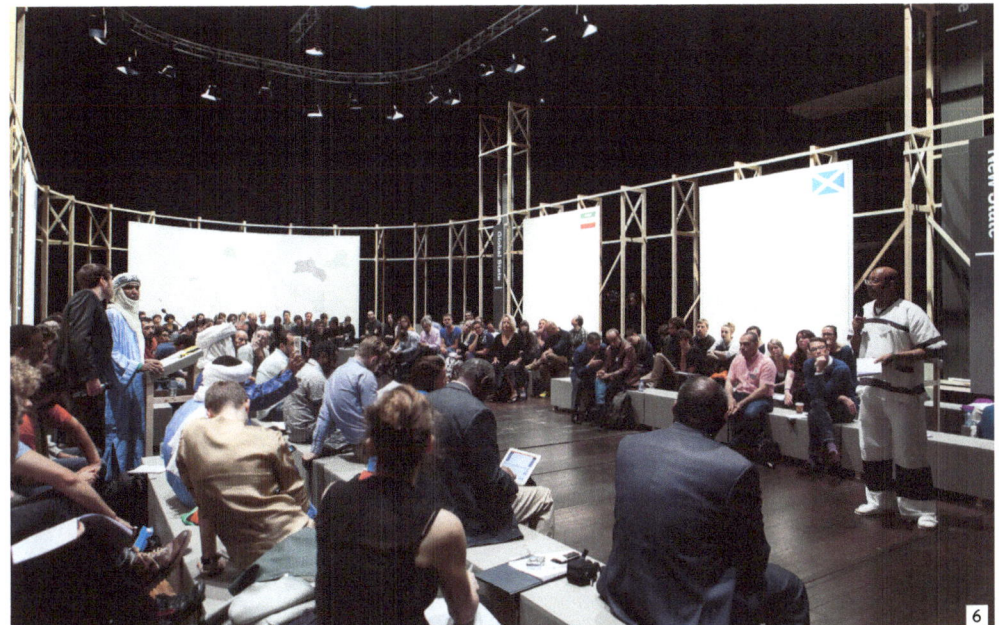

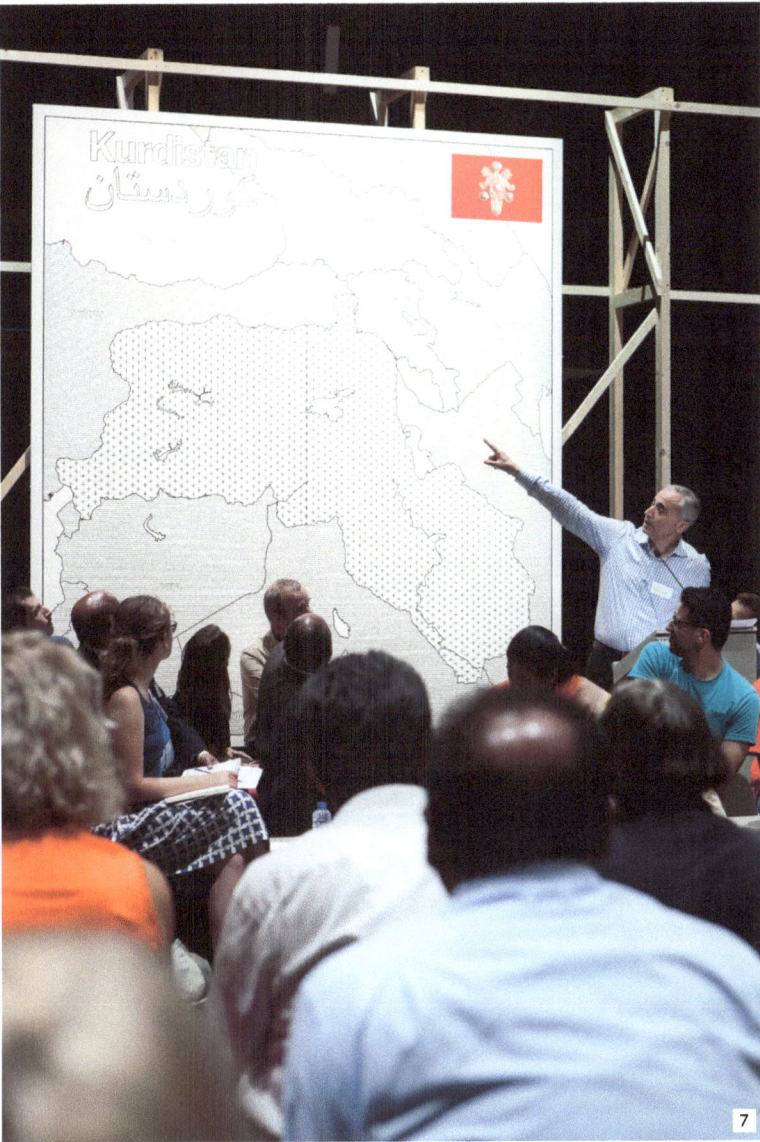

Proposal for Hungary, 1945
Zoltán Kékesi, Szabolcs KissPál, and Máté Zombory

In January 1945, Hungary is a country divided. On the Western side, the Nazi-allied Hungarian establishment and Army continues its fight against the Soviet forces, while on the liberated Eastern side, post-war reconstruction is already beginning. The question of political-legal retribution is raised both by National Committees of local municipalities, and by the Provisional National Government. Actual historical justice commences in the capital, where on 28 January the newly founded National Committee of Budapest establishes the People's Law-Court. According to its first verdicts, on 4 February, one day before the governmental decree on the formation of the people's law-courts goes into effect, two death sentences are publicly executed in the city.

Our project imagines a Truth and Reconciliation Commission to be convened in Hungary in 1945, based on the model developed in South Africa half a century later. The commission would investigate political crimes committed before 1945. The idea is to replace or complement the model of retributive justice applied in the post-war trials in Hungary (and elsewhere in Europe, most prominently in Nuremberg), with a more restorative model. The project is composed of a "Decree on the Formation of a Truth and Reconciliation Commission in Budapest" that appropriates parts of the Promotion of National Unity and Reconciliation Act (1995) and a "Decree on the National Flag of Hungary." The flag, inspired by the idea of the post-apartheid flag of South Africa, comprises a traditional Hungarian national symbol, historically appropriated by the radical right (red and white stripes), a traditional Jewish symbol (blue and white stripes), an element of the international flag of the Romani people (the spoked-wheel), and an element from the flag of the Hungarian Germans, expelled collectively after 1945 (the castle with the open gate).

Decree on the Formation of a Truth and Reconciliation Commission in Budapest. Adopted at the first meeting of the five-member committee of the National Committee of Budapest
28 January 1945

To provide for the investigation into and the establishment of as complete a picture as possible of the nature, causes, and extent of the catastrophe that happened to the Hungarian people, rooted in the period between 21 March 1919 (proclamation of the Hungarian Soviet Republic) and 20 January 1945 (signing of the armistice agreement in Moscow by the Hungarian Provisional National Government and the Allied Powers, especially to uncover crimes emanating from the conflicts of the past, and the fate or whereabouts of the victims;

To disclose all past deeds contributing to the evolvement of the catastrophe; any act during the said period committed against the people that forcefully realised violent and oppressive discrimination toward certain layers of Hungarian society, according to race, religion, class, belief, or sex; any contribution to the adoption or execution of laws and decrees that worked or work seriously against the interests

of the people; cruel treatment by the authorities after 1 September 1939 in executing laws and decrees against certain layers of the society; public distribution of fascist and anti-democratic propaganda, arousing and supporting racial and denominational hatred, committing violence against women of any race, religion, class, or belief in or collaboration with organisations serving the persecution of certain layers of society; voluntary function or membership in anti-democratic parties or organisations; public promotion and support of anti-popular and anti-democratic measures;

To afford victims an opportunity to relate the violations they suffered in the overall national catastrophe, and to report to the Nation on such violations and victims;

To grant amnesty to persons who make a full disclosure of all the relevant facts relating to acts committed against the people with a political objective in the course of the conflicts of the past during the said period;

To foster the taking of measures aimed at the granting of reparation to, and the rehabilitation and the restoration of, the people sacrificed meaninglessly during the catastrophe; the making of recommendations aimed to establish political and social guarantees that the catastrophe will never again happen in any form in the future;

To provide an opportunity so that the Hungarian people themselves can establish the truth of the past and the justice in history to attain reconciliation between the people of Hungary and the reconstruction of society;

To enable that the individual cases of sacrifices and sufferings trace out the grievance of the whole Hungarian people;

And, for the said purposes, to provide for the establishment of a Truth and Reconciliation Commission, and to confer certain powers on, assign certain functions to, and impose certain duties upon that Commission; and to provide for matters connected therewith.

SINCE it is deemed necessary to establish the truth in relation to past events as well as the motives for and circumstances in which the catastrophe occurred, and to make the findings known in order to prevent a repetition of such acts in the future;

AND SINCE the National Committee of Budapest states that in order to advance such reconciliation and reconstruction, amnesty shall be granted with respect to acts, omissions, and offences associated with political objectives committed in the course of the conflicts of the past;

AND SINCE the National Committee of Budapest exercises executive power on the territory of the city until the Provisional National Assembly is fully constituted that is destined to adopt a law providing for the mechanisms, criteria, and procedures, including tribunals, if any, through which such amnesty shall be handled;

BE IT THEREFORE a juristic person to be known as the Truth and Reconciliation Commission established by the National Committee of Budapest.

(1) The objective of the Commission shall be to promote national unity and reconciliation in a spirit of understanding that transcends the conflicts and divisions of the past.

(2) The Commission shall consist of a Chairperson, a Vice-Chairperson and not more than ten persons who are fit and proper persons, impartial, do not have a high political profile, and are broadly representative of the Hungarian community.

(3) The Commission shall provide an opportunity to reconstruct the history of the catastrophe from the perspective of both the victim and the persecutor and to reach to a common understanding of the past events.

(4) The Commission shall facilitate the granting of amnesty to persons who make a full disclosure of all the relevant facts relating to acts associated with a political objective and who comply with the requirements of this proposal.

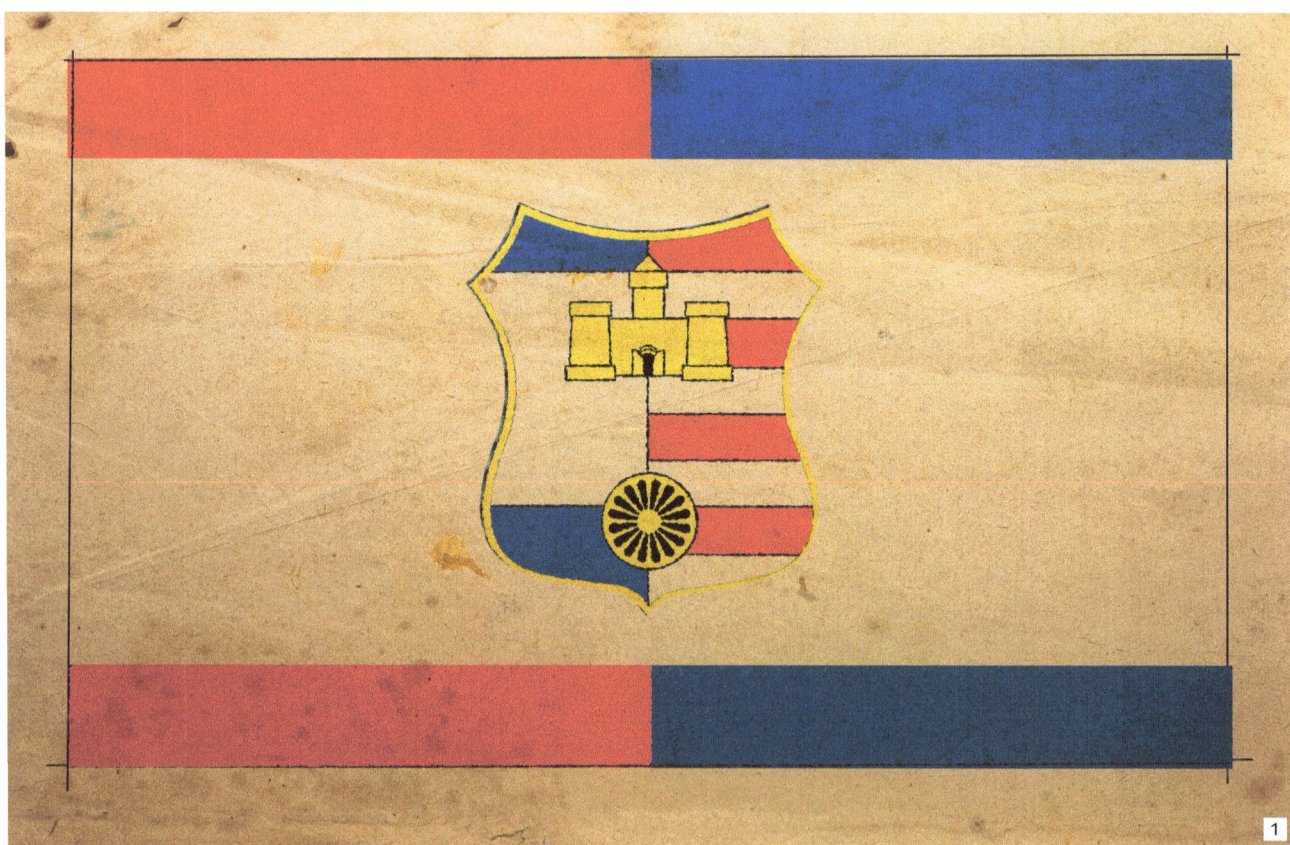

Decree on the National Flag of Hungary
Adopted at the first meeting of the 5-membered committee of the National Committee of Budapest
28 January 1945

The National Committee of Budapest proposes a national flag that provides a historic bridge between the past of a deeply divided society characterized by oppression, strife, conflict, and injustice, and a future founded on political self-governance and social equality, democracy, and peaceful co-existence for all Hungarians, irrespective of race, religion, class, or belief.

The National Committee of Budapest expresses that the pursuit of national unity, the well-being of all Hungarian citizens, and peace require reconciliation between the people of Hungary and the reconstruction of society;

that there is a need for understanding but not for vengeance, a need for reparation but not for retaliation, a need for solidarity but not for victimization;

that in order to achieve the said purposes, a new and truly national flag is necessary for Hungary, constructed and designed as a common task, in which the making of the symbol expressing the unity of the nation in itself contributes to national solidarity; the national flag should comprise elements of symbols of the Magyar, Jewish, German, and Romani peoples, and open a gate for all past, present, and future groups in Hungary;

THEREFORE decided upon the production of a proposal, representing the will of the people of Budapest, for the future Hungarian national flag.

Zoltán Vas (Hungarian Communist Party)
Dr. Imre Oltványi (Independent Smallholders' Party)
István Ries (Social Democratic Party)
Ferenc Farkas (National Peasant Party)
István Kossa (Trade Unions)

Also present:
Dr. György Gulácsy, Secretary General of the National Committee of Budapest
Dr. János Csorba, Mayor of Budapest
Péter Bechtler and Alajos Jámbor, Vice Mayors

Zoltán Kékesi *(born 1976, Budapest) is a writer and cultural researcher. He has been associate professor in the Department of Art Theory and Curatorial Studies at the Hungarian University of Fine Arts, Budapest since 2009. In 2014-2015, he was a Prins Foundation senior research fellow at the Center for Jewish History, New York. His most recent book is* Agents of Liberation: Holocaust Memory in Contemporary Art and Documentary Film, *featuring case studies on German, Polish, and Israeli artists (Hungarian edition 2012, English edition from the Central European University Press in 2015). His current research investigates the visual and cultural history of modern anti-Semitism and the radical right with a focus on Central and Eastern Europe.*

Szabolcs KissPál *(born 1967) is an artist based in Budapest and assistant professor in the Intermedia Department at the Hungarian University of Fine Arts. He works in various media from photography to video, from installation to objects and conceptual interventions. His main field of interest is the intersection of new media, visual arts, and social issues. Besides his art practice, he also publishes critical texts about contemporary visual culture. Since 2012, KissPál has developed an activist practice by starting up and maintaining a blog, by establishing, together with other artists, a protest group called Free Artist, and by taking part in various civil disobedience actions.*

Máté Zombory *(born 1975, Budapest) is a sociologist and research fellow at the Centre for Social Sciences, Hungarian Academy of Sciences, Budapest, and assistant professor at Tomori Pál College, Kalocsa, Hungary. Currently he is a post-doctoral research fellow at Collegium de Lyon, France. His book* Maps of Remembrance: Space, Belonging and Politics of Memory in Eastern Europe (2012) *is a study on critical geography and national identity., Currently he is interested in the history of normative discourses on the past: a project of his studies the genealogy of the memory of Communism in Europe, and another focuses on the political relevance of the past in early post-war Hungary.*

On Michal Heiman's Return: Asylum (The Dress) 1852–2017

Michal Heiman, artist, curator, lecturer and theoretician, creator of the *Michal Heiman Tests No. 1-4 (M.H.T.s)*, is currently working on a project titled *Asylum (The Dress) 1852-2017*, which seeks to find ways to revisit women, photographed in the 1850s, while hospitalized at Springfield Hospital, the former Surrey County Lunatic Asylum. While completely immersed in the process of articulating new ideas concerning the infrastructure of photography as a field of power-relations empowered strongly by the site of libidinal exchange, and which is akin to sexual attraction– dangerous, inescapable, immediate, and incestuous–Heiman had a radical encounter with a photograph.

She came across THE FACE OF MADNESS: HUGH W. DIAMOND AND THE ORIGIN OF PSYCHIATRIC PHOTOGRAPHY (1976). The book, edited by Prof. Sander Gilman, includes fifty-four plates of photographs and engravings of patients, mainly women, taken by the British physician Hugh Diamond (1809-1886) at the Surrey County Asylum. Dr. Diamond first exhibited his photographs in 1872, but from the 1860s until his death in 1886, he rarely made or exhibited any photographs, and most of the photographs have been lost. The book presents both the engravings and the photographs, thus inviting reflection on the difference between the two forms of representation. Looking at the cover of the book, which depicts a woman in a checked dress holding what seems to be a dead pigeon in her lap, as well as reading descriptions of case studies in it, Heiman arrived at Plate 34–a photograph that sent her on an unexpected new journey.

The young woman staring at Heiman in Plate 34 looked exactly like the adolescent her. Heiman even recognized her singular hands. Her first reaction was to sew herself a similar dress with the help of a seamstress, and in 2012 she started to employ different strategies of gaining access to the Asylum. She took multiple portraits (still photography and videos) of herself and a few dozen people, mainly women, wearing the dress. These included family members, friends, psychoanalysts, artists, doctors, activists, architects, curators, poets, and others. Although the project investigates a period with countless dark sides, it does not reject absurdity, and calls for a suspension of disbelief.

How can we return to a moment when women had neither rights nor power and function in it? Confronting the multiple interpretations of the complex and highly charged notion of "return," Heiman raises a myriad of issues relative to human rights, and more specifically to women's rights. In applying various subversive techniques to draw out their meaning, she uses the "archive" (Plate 34), the "uniform" (the checked dress), the phenomenon of psychoanalytical regression, and other different radical and dicey strategies (some are better kept secret), in the hope that some of them will open the asylum door, as well as forge the path for other "rights to return."

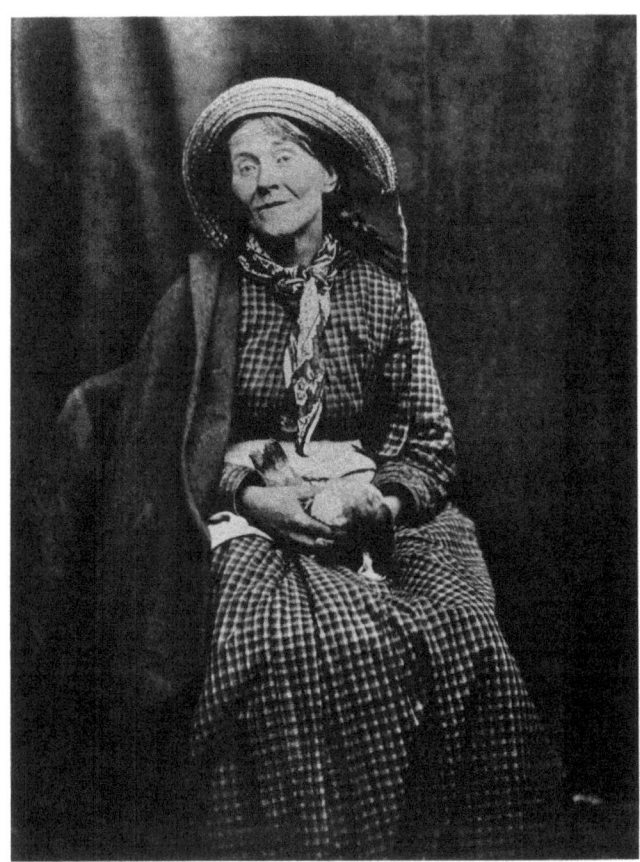

Plate 27 (also the cover image), by Dr. Hugh W. Diamond, 1850s, from *The Face of Madness: Hugh W. Diamond and the Origin of Psychiatric Photography* (1976)

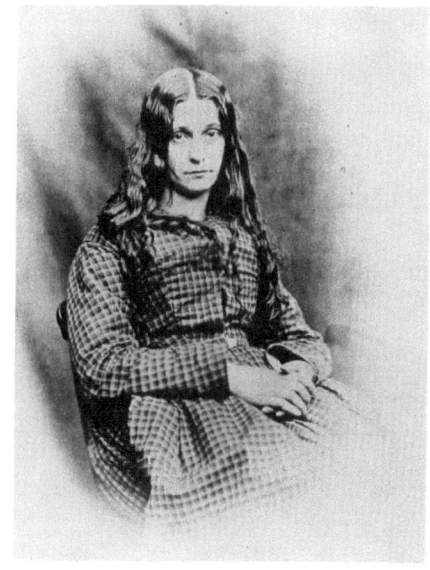

Plate 34, by Dr. Hugh W. Diamond, 1850s

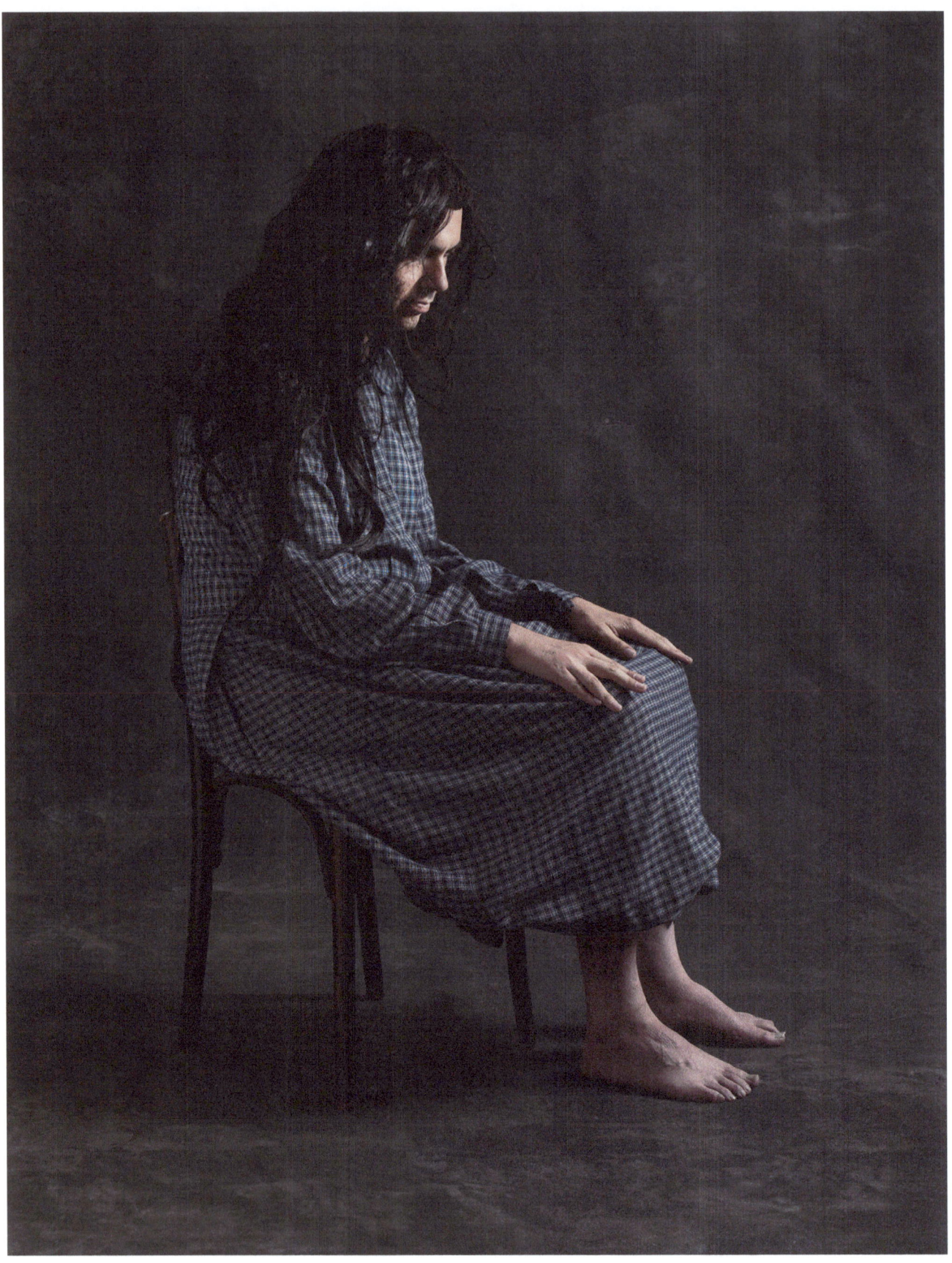

Eran Hadas (b. 1976), programmer, poet, and new media artist from Tel Aviv. *Asylum (The Dress) 1852-2017*, 2015.

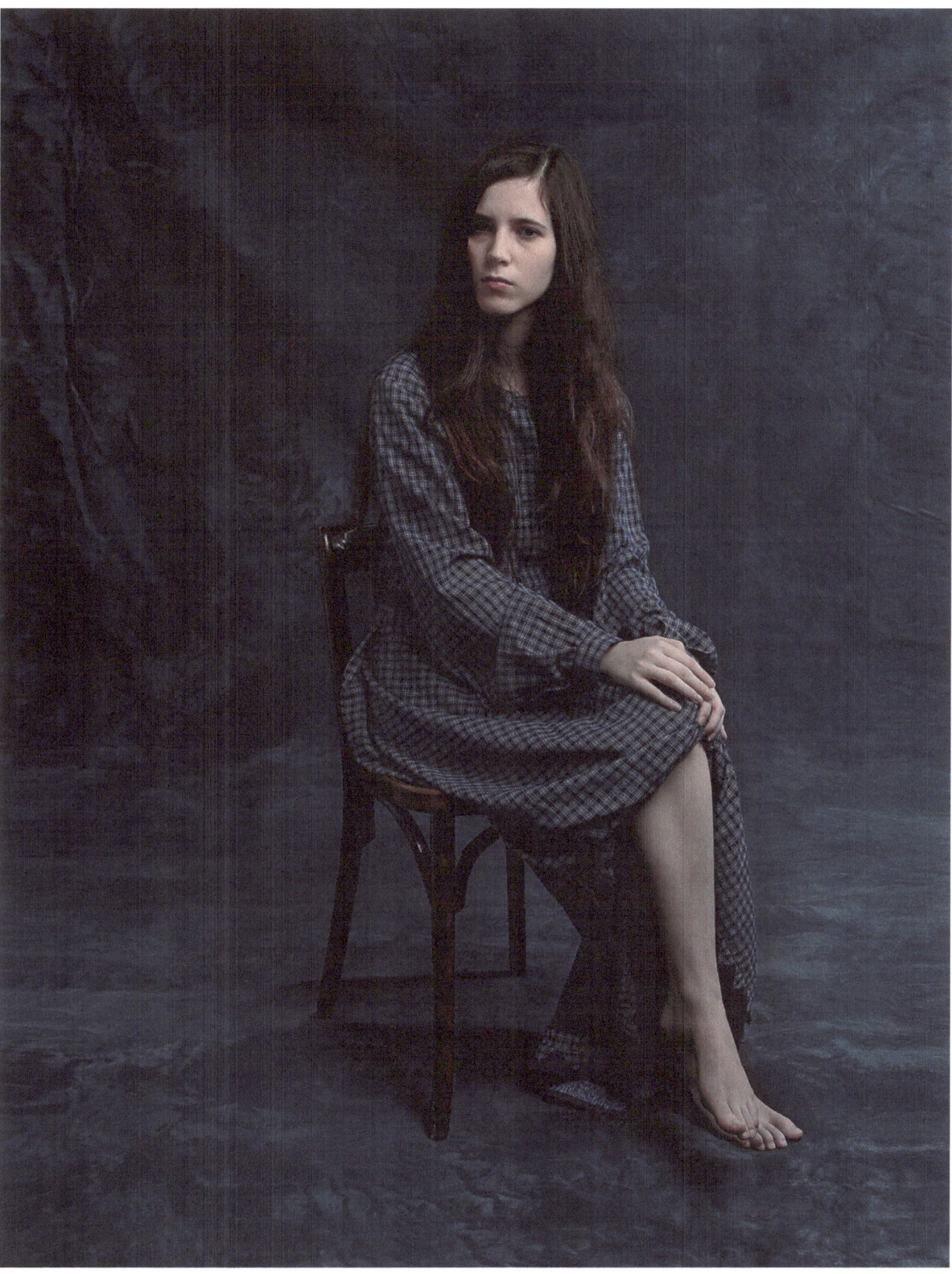

Camea Smith (b. 1992), student of art at the Bezalel Academy of Art & Design. *Asylum (The Dress) 1852-2017*, 2013.

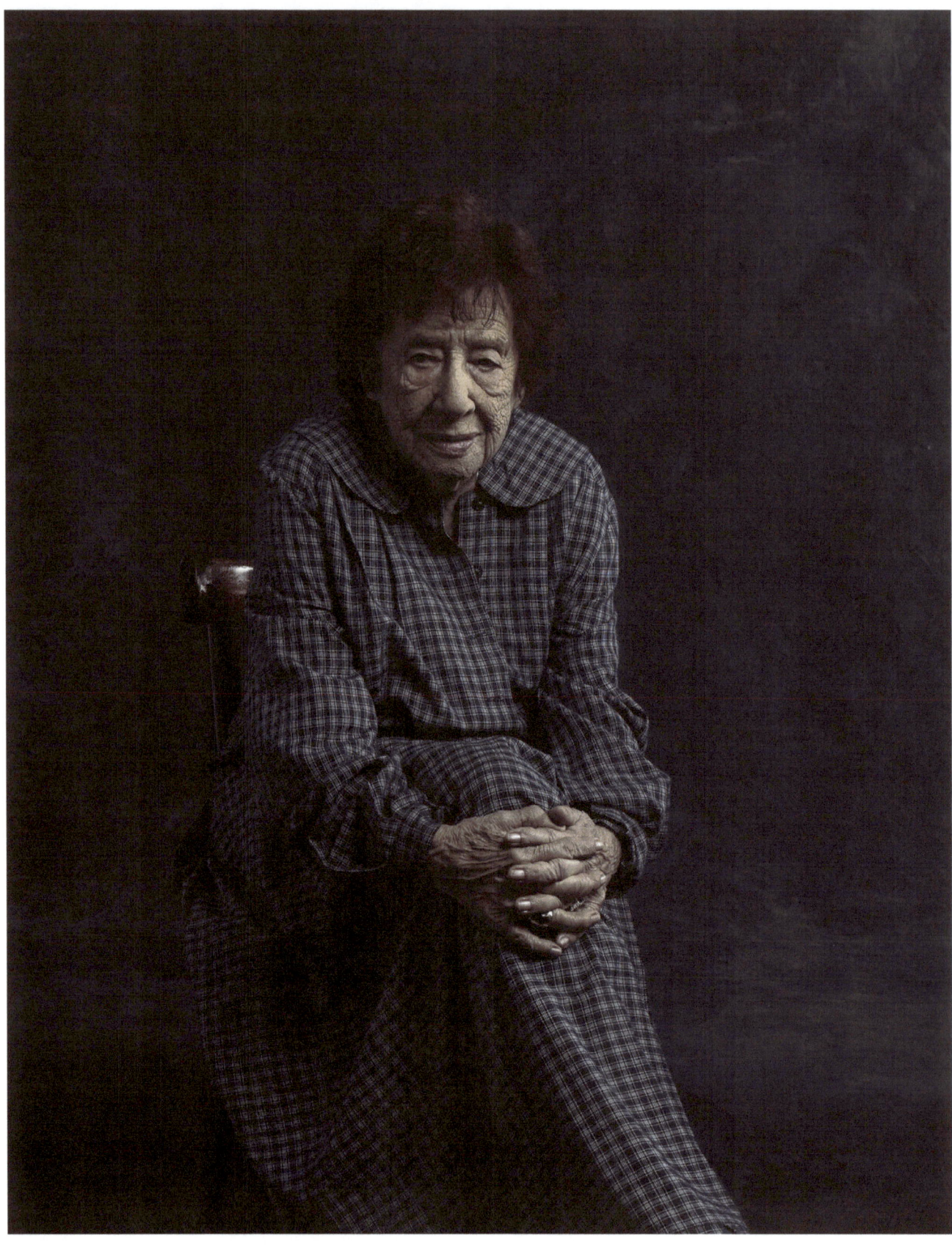

Phyllis Palgi, anthropologist (1920-2015). *Asylum (The Dress) 1852-2017,* 2012

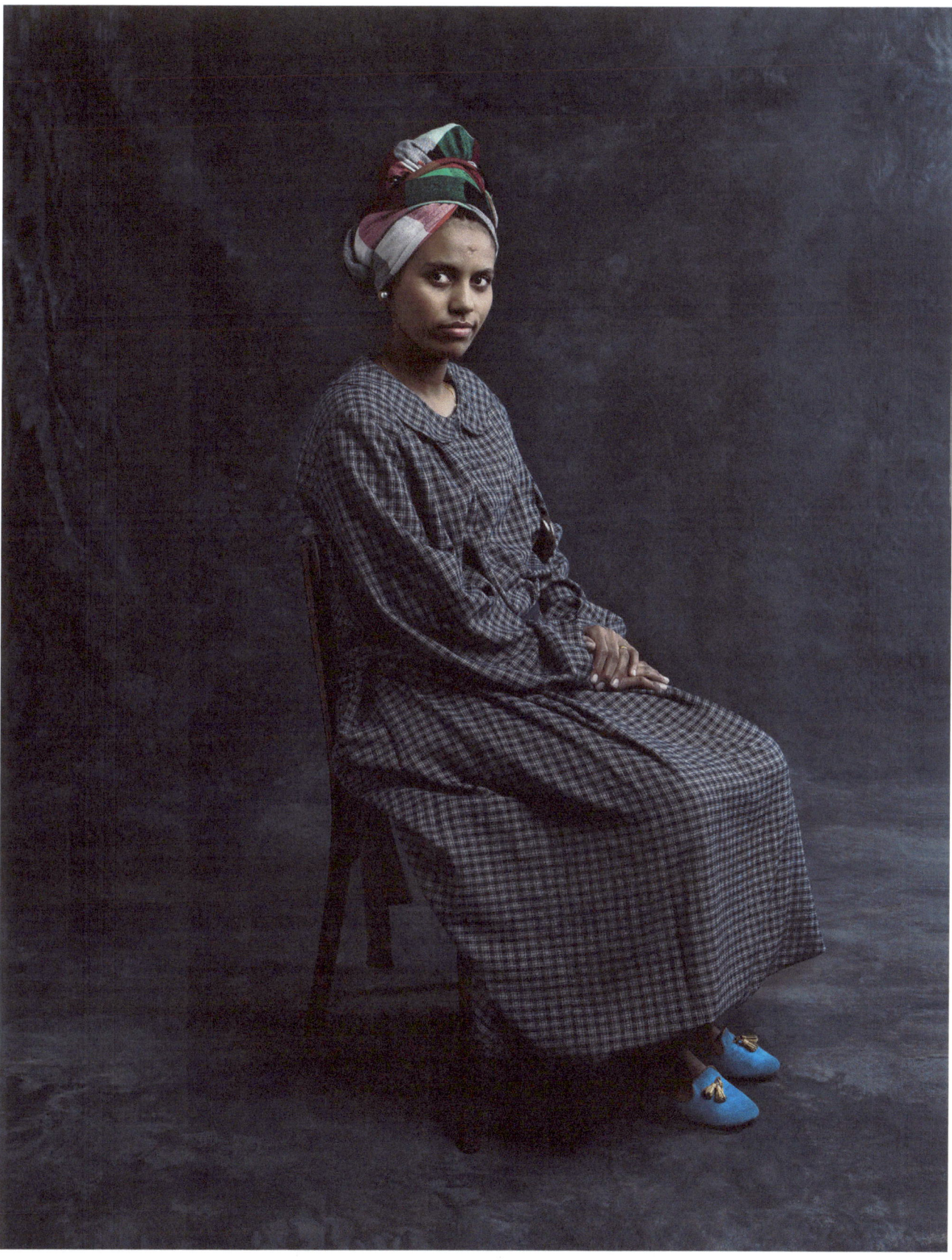

Asmait Yohannes (b. 1989), asylum seeker from Eritrea (lives in Tel Aviv). *Asylum (The Dress) 1852-2017*, 2012.

Testimony, 2013
Lawrence Abu Hamdan

Judge Please listen very carefully to the questions that are asked of you; please speak loudly, clearly, and slowly so that we can make an accurate record of everything you say ... Are you happy to proceed?

Lawrence Abu Hamdan Yes.

Defense Can you tell us your name please?

LAH My name is Lawrence Abu Hamdan ...

Judge You are quite quietly spoken, can you try to keep your voice up?

Defense First of all, can you tell us how you met the appellant?

LAH Yes, sure. I was making a radio documentary about the policy which is referred to as LADO, the immigration policy, which is Language Analysis for the Determination of Origin, and when making that documentary I interviewed forensic linguists, lawyers, defendants of asylum seekers, and asylum seekers themselves who had been through the process of language analysis for determination of origin. I spent around a year making that documentary, and in November of 2011 I first met Mohammad Barakat who—

Prosecution Sorry to interrupt, sir–can you speak slower?

LAH Ok ... So, slower ... In November 2011 I met Mohammad, because it became known to me that he was someone who had been through the language analysis for determination of origin and his investigation had been conducted by Sprakab and that's what I wanted to talk to him about. So we met for an interview in Elephant and Castle and since then I have become close friends with Mohammad.

Defense Obviously you are aware of the background of his case and you are aware that the Sprakab report found that he was of North African origin, which is contrary to the claim of Mr. Barakat that he is Palestinian ... What's your own language background?

LAH I was born in Jordan, in Amman, and I speak Arabic, the Levantine Arabic dialect. My own language background, just like many people from the Middle East, is quite itinerant, in the sense that, well, my mother is English so I also speak English as a mother tongue, but being Druze, from the ethnic minority Druze, means that a lot of the linguistic traits of the Druze are not necessarily Jordanian as such, because the Druze originate from Syria and Lebanon and so does the type of language of those people. So yeah, my spoken colloquial Arabic comes from Jordan, Lebanon, and Syria.

Defense Do you speak a dialect spoken in Libya?

LAH No, most certainly not. I don't in fact understand any dialects from Libya or North Africa. In 2011 that was made clear for me, when all the news was heavily focused on Libya and North Africa and I really couldn't follow the language there at all. Because a lot of my life was spent here in the United Kingdom and I don't have the kind of experience of watching Egyptian cinema or these kinds of things which are usually the things that educate people to the other Arabic dialects.

Defense What language do you communicate to Mohammad in?

Prosecution Presumably you understand that Sprakab has been given very considerable weight by the immigration tribunal and that we have previously overruled an appeal against it. So why do you claim that Sprakab and language analysis is so problematic?

LAH Because when I was making this documentary I interviewed a lot of linguists and I read guidelines authored by over one hundred linguists that all attest to the use of language analysis for the determination of origin. One of the reasons they give is because as linguists, as scientists, they see that the way people speak does not always correlate with their national origin, that there are many other factors to be considered. So that's one big problem they have with Sprakab's verdicts. They also have a problem with the fact that linguists, or the people who do

the analyses, are anonymized. If we measure that against other criminal courts you would never have an expert witness anonymized. It is also problematic as one's dialect can of course change when one speaks to different people. We change the way we speak to make ourselves better understood. Of course the language analysis does not take into account the fact that dialects don't stop at a border, that dialects are much more porous than borders.

Prosecution You are not suggesting that Sprakab is biased?

LAH Linguist Dr. Peter Patrick, who is known to the court, told me that when the home office was vetting the different companies that could perform LADO they did not do a blind test, where they give the company voices to analyze that they already know the answer to; so they did not get them to analyze voices of people whom they already knew the origin of. Rather than do these blind tests to see who is the most efficient and best at performing LADO, they simply chose the company with the highest rate of rejection, which was Sprakab.

Judge In relation to your piece on Sprakab and LADO, did you reach a conclusion about the efficacy of Sprakab?

LAH I concurred with the linguists whom I interviewed, who essentially are against its use to determine people's origin, because of the basic fact that a voice or an accent should not exist as a kind of passport.

Judge But do you find that Sprakab could work using the methodology that they use, with some tweaking, or do you find that the process is wholly wrong?

LAH I think it needs to be much more thorough if it is to work. I think that twelve-minute interviews are not sufficient. I think it needs to take into account the people's biographies much more than simply where they come from.

Lawrence Abu Hamdan
Beirut-based artist Lawrence Abu Hamdan's work frequently deals with the relationship between listening and politics, borders, human rights, testimony and truth through the production of documentaries, essays, audiovisual installations, video works, graphic design, sculpture, photography, workshops, and performance. Abu Hamdan's interest in sound and its intersection with politics originates from his background in DIY music. The artist's forensic audio investigations are conducted as part of his research for Forensic Architecture at Goldsmiths College London where he is also a PhD candidate and associate lecturer.

In the following pages: a photograph portrait series of Mohamad, the protagonist of Abu Hamdan's audio documentary The Freedom of Speech itself, 2012. Mohamad is an undocumented asylum seeker from Palestine living in the United Kingdom. He now faces deportation because the UK authorities claim that he mispronounced 3 words in a highly unscientific "accent test" they had subjected him to in order to verify his origins. In a state of limbo and currently unable to work, in this portrait series he is captured while de-installing Abu Hamdan's exhibition and seen erasing the work "two you" depicting voice-fingerprints from the wall.

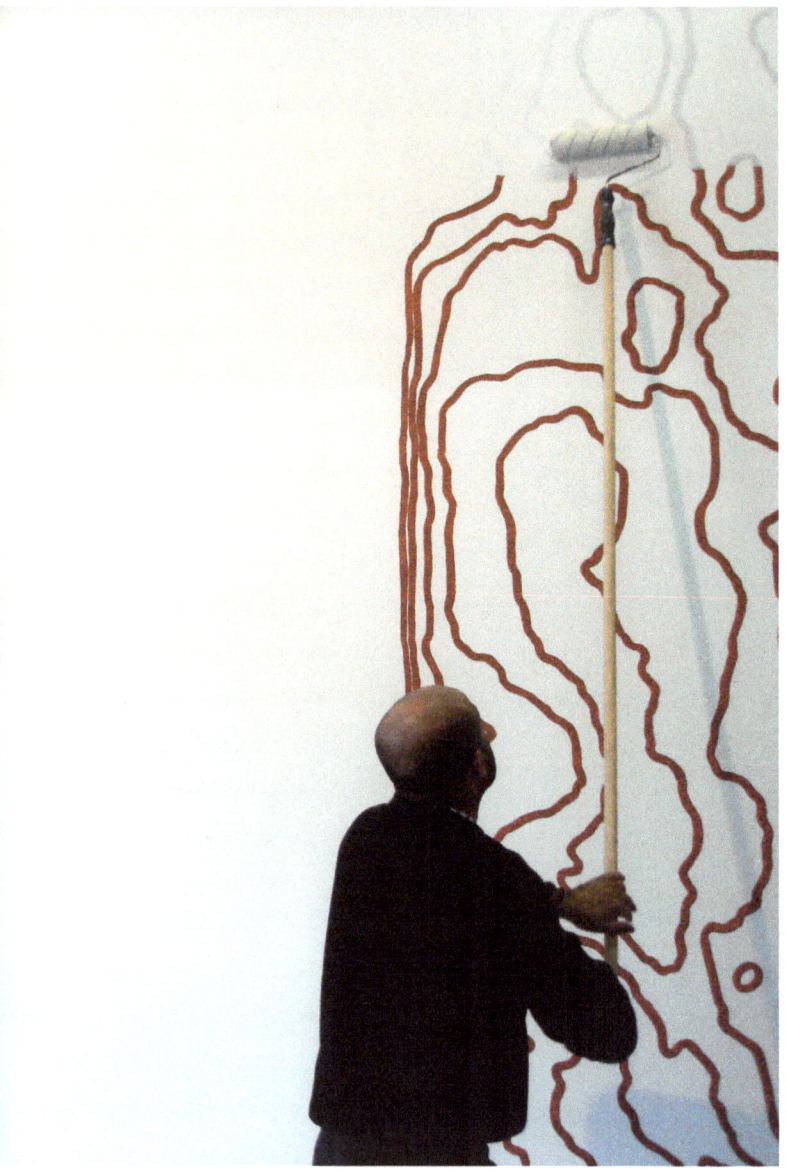
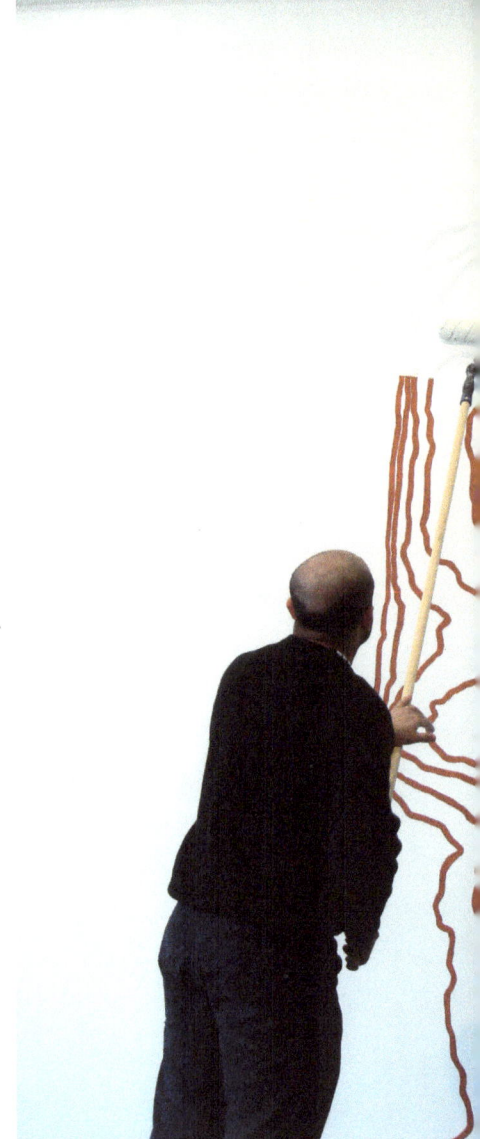

The Artist as an Expert Witness
Avi Feldman

The audio documentary *The Freedom of Speech Itself* (2012) created by artist Lawrence Abu Hamdan was submitted as evidence to a UK asylum tribunal in 2013. Following this, the artist was called to testify on his findings regarding the use of language analysis for the determination of origin (LADO). In his testimony, published in the current issue of *OnCurating*, Abu Hamdan was requested to state his opinion on the case of asylum seeker Mohammad Barakat whom he met during the process of making the documentary.

During the testimony it is revealed to us how a method of screening executed from afar determines the application of an asylum seeker. Following a voice analysis procedure conducted in the form of a twelve-minute phone interview, Barakat's claim to be identified as Palestinian was rejected, and he was declared to be of Northern African origin. Conducted with minimal human contact by the Swedish company of Sprakab, and paid by the UK government, LADO is able to revoke one's identity solely on the ground of voice or accent. Abu Hamdan's testimony attests against the very basic notion of the nation-state as it relies on fictitious borders and regulations to assert pertinence. According to him, unlike state-made borders, "Dialects don't stop at a border, […] dialects are much more porous than borders." This statement, as innocent as it might appear at first, calls upon our imagination as it brings to mind a different era when movement in the world was more fluid.

We tend to assume that we are enjoying now a freedom of movement like no time before. But in fact, border controls have never been stricter than they are nowadays. "In the last decades before the Great War, most travelers entered and left the countries of their choosing without a passport. All of this ended during World War I, as European governments sought to reinforce security and control the emigration of citizens with useful skills. Such controls stayed in place after the war and became enshrined in international agreements".[1] As border fences are currently being built by countries such as Hungary, and the EU is implementing extreme measures of border control through external agencies such as Frontex, Abu Hamdan's statement demands us to imagine a different future embedded in a different past.

In the region known as the Middle East up until the end of the nineteenth century, movement has been much freer than most of us can possibly imagine. An appropriate description of movement and exchange in the region can be found, for example, in a conversation between Artur Zmijewsk, artist and curator of the 7th Berlin Biennale, and curator Galit Eilat as she states that, "Before the British came to the Middle East […] people would travel to Damascus in Syria to study, go back to Jaffa, and visit Beirut for vacation."[2] Similarly to Abu Hamdan's testimony, Eilat wishes for us to be able to imagine a world where nation-states are obsolete. According to Eilat, the re-writing of reality as we know it can be achieved through artistic imagination when it is working in partnership "with academics, lawyers,

psychologists, sociologists, and so on."³ This method of collaboration with practitioners from other fields is far from being new to the contemporary art world. Abu Hamdan has also testified how his work is developed through collaboration with linguists just as with lawyers. It is due to this that Abu Hamdan was able to find a way to erode a seemingly objective-based method. LADO, according to Abu Hamdan, is far from being an innocent, quick, and reliable mechanism deciding on the origin of the asylum seeker. When it is put into operation by governments, it is not only because an applicant does not hold valid identification, but is often times based on a political motivation to discredit the applicant in question.

The testimony of Abu Hamdan, just like the conversation between Eilat and Zmijewski, brings to mind the amount of knowledge and tools of imagination accumulated by artists and curators alike throughout their work and research. Their insights, deriving also from collaboration with scholars and practitioners from other fields, intrigue me to further investigate the notion of artists and curators as experts. More specifically, I am interested in exploring the sort of training and expertise curators and artists possess that could also be of interest in the legal sphere when called upon to testify as an expert witness, just as in the case of Abu Hamdan.

We might be accustomed to think that the definition of the expert witness serving the courts has been certain since the dawn of time. We might also believe that artists or curators must be far from reaching a point in which they might hold a decisive role in the legal system. Yet, a closer look into the evolution of the role of the expert witness shows much to the contrary. Only as late as 1975 have the *Federal Rules of Evidence (FDE)* been codified in the USA. Even with these rules in hand, the definition of who is an expert remains open to interpretation: "If scientific, technical, or other specialized knowledge will assist the trier of fact to understand the evidence or to determine a fact in issue, a witness qualified as an expert by knowledge, skill, experience, training, or education, may testify thereto in the form of opinion or otherwise."⁴ Therefore, I wish now to provide a short history of the development of the concept of the expert witness in the English legal system (Common Law). By doing so, I shall expose the ever-changing definition and reaction to the expert witness and to evidence as it has been debated by courts, scientists, and the general public. At the end of this overview, I will return once again to Abu Hamdan's testimony as I aspire to further introduce the possibility of integrating artists (and curators) as expert witnesses in the legal system.

By the end of the eighteenth century, the adversarial legal system—in which a judge moderates the contest between two differing parties—has taken full form. Alongside this development and changes in litigation, there has been a need to newly understand the expert witness role. As the role of judges in the courtrooms changed to be more passive and neutral while lawyers became more powerful and active in examining their witnesses, a new place had to be found for the expert who previously had appeared either as court advisor or as a member of the jury. Tal Golan in his book *Laws of Men and Laws of Nature* offers a detailed historical view of the expert witness—a figure known to the courts from as early as the fourteenth century. Golan, however, suggests that it has taken many years for the legal system to find and define the categories on which to base the expert's role. From a state of exception to the rule of law, the role of the expert grew in its influence to become an important fixture in all legal procedures. Based on Golan's book, I will emphasize in the following how from being considered during the 18th century as not much different from any lay witness, the position of the expert has gone through several

phases until being recognized by the courts as holding a significant level of knowledge and expertise.

It is generally agreed upon by legal researchers that up until the case of *Folkes v. Chadd* (1782), the expert witness was far from being accepted as a definite legal entity. Lord Mansfield, who ruled in this case in favour of accepting as proper evidence the judgment of an expert, is regarded as "the onset of judicial recognition in the modern practice of party-called expertise."[5] Nevertheless, it is not to be overlooked that since 1782 the court's understanding of the expert has gone through significant turmoil. Also in the public eye, the expert enjoyed times of approval as well as times of increasing amounts of doubt and mistrust. For instance, by the middle of the nineteenth century, we notice a sustainable shift in the acceptance of the expert witness both by the public and the courts. If at times the court has recognized the value of the expert as "the most decisive and convincing of them all," doubts erupted regarding the true value of the expert. As many of the experts during that time did not yet hold a university degree to prove their scientific knowledge, and "Their expertise was not based on any regulated training but rather was self-thought," the courts "classified them as 'men of skills', a broad legal category that included all other traditional experts–mechanics, navigators, and so forth."[6]

While courts of those days were reluctant to define expert witnesses as professional men of science and pay them accordingly, it turned out that this was not the case for "the soaring technical industries of the nineteenth century, which were more than happy to pay men of science extravagant amounts to represent them in court in their brawls over patent rights."[7] The drawback of this development has been the growing decline in trust towards the expert witness, as they were seen as willing to defend any side as long as they were well compensated. "Judges found it therefore exceedingly difficult to accept the fact that similar experiments were constantly producing antithetical results when conducted by opposed experts. Such conflicting experimental results, they believed, reflected the partisanship of the scientific experts who produced them, and since these experts were highly paid for their services, their conduct was perceived as the prostitution of science, of selling its credibility to the higher bidder."[8]

The flourishing condemnation towards expert witnesses could not be ignored by the scientific community, as it undermined "the epistemological, ethical, and social conventions of the Victorian scientific community."[9] As a result, a special committee was formed in 1860 by the British Association of the Advancement of Science, and following two years of investigation it published its findings. Its main recommendations were "getting rid of the jury in civil cases of technical character" and "to create […] a court, where the bench would only consist of a judge and up to three skilled assessors […] also be allowed to call on witness independently of the parties."[10] However, not being able to implement the committee's resolutions, or to arrive to a clear definition of who is an expert and what sort of training an expert should hold, has left both legal and science practitioners in a state of bafflement.

At first, rigorous advancements in science and technology of the end of the nineteenth century did not make matters any easier. The introduction of photography and x-ray images brought about further bewilderment and perplexity within the legal system. A system based on words rather than on images, and already in doubt regarding the role and qualification of experts of science, found itself in further disarray. Invented in 1895, x-ray technology was initially received by the legal system with scepticism. Yet, as photography has already been much debated and finally accepted by the courts as illustrative evidence, by 1901 several Supreme

Courts in the USA ruled that x-ray images should be regarded as a form of photography, and hence admitted as evidence. Now the debate was left once again to the threshold of the expert, as it was not clear whether a jury could alone interpret the images, or whether an expert would be needed. A great commotion arose within the scientific community, only to subside with the introduction of the field of radiology. With the help of radiology, x-ray images "ceased to be a part of the layman's universe,"[11] and the medical specialist was beginning to be gradually perceived by the courts as an established and reliable source of authority on the subject.

Hence, initially new means of evidence such as photography and x-ray images were seen as deepening the confusion regarding applicable evidence and the role of the expert. Yet, once accepted by the courts, another shift occurred as the interpretation of evidence was entrusted to the expert witness. Instead of providing judges and juries a direct and easy access to understanding evidence, a new role and position was passed on to the expert witness. It turned out to be that new technology, along with progress in the medical field, "was turning into exclusive domain, accessible to experts alone."[12]

As the above review suggests, the evolution of the role of the expert witness has not been a linear one, but one steeped in debate and criticism by courts and scientists, and by mass media and the general public alike. Against this backdrop, bringing back into the discussion the work of Lawrence Abu Hamdan, I wish to examine from a contemporary perspective the positioning of an artist as an expert witness. The testimony of Abu Hamdan deals, as discussed earlier on, with language analysis as evidence in claims of asylum seekers. For the last fifteen years, Sprakab has been conducting phone interviews with asylum-seeking applicants on the request of different governments worldwide. The use of Sprakab analysis has peaked since the 1990s, to include not only Scandinavian countries, but also other European countries, as well as Canada, Australia, and New Zealand–this in face of growing criticism towards the reliability and the justification of the company's analysis. Similarly to the high degree of uncertainty and doubt towards expert witnesses and evidence such as photography and x-ray images, in 2015 it was published in the press that the Swedish company Sprakab "misled the Home Office about the reliability of one of its analysts."[13]

The invitation of an artist to serve as an expert witness in an asylum tribunal offers a possibility to further dismantle the expertise of companies such as Sprakab, while also posing the crucial question of who is an expert. The artist's evident expertise does not only underline the politically biased use of language analysis, but also opens up new paths for artists (and curators) to gain an active role in policy making and legal matters as they engage the courts with artistic and curatorial forms of imagination. Throughout his work, Abu Hamdan has gained extensive expertise on the matters of sound and voice recognition, and his criticism towards language analysis as it is used in the case of asylum seekers is also shared by linguistic scholars.[14] New forms of evidence and witnessing, as in the matter of sound research in the work of Abu Hamdan, will require the courts to re-examine their own legal methods and practices. At a time when Europe is facing one of the most significant surges of migrants and refugees since World War II, his work is ever more vital for our understanding of the problematic mechanism of language analysis, just as of the role artists can and should have in the legal system.

Notes

1 Marcus Walker and Jon Sindreu. "Passports, 100 Years, 100 Legacies." *The Wall Street Journal.* http://online.wsj.com/ww1/passports

2 Artur Zmijewski Joanna Warsza, eds., *7th Berlin Biennale for Contemporary Art: Forget Fear,* Walther König, Köln, 2012.

3 Artur Zmijewski, Joanna Warsza, eds., op. cit.

4 Tal Golan, *Laws of Men and Laws of Nature: The History of Scientific Expert Testimony in England and America,* Harvard University Press, 2007, p. 261.

5 Ibid., p. 41.

6 Ibid., p. 69.

7 Ibid., p. 81.

8 Ibid., p. 89.

9 Ibid., p. 106.

10 Ibid., p. 122.

11 Ibid., p. 205.

12 Ibid., p. 205.

13 Chris Green. 2015. "Sprakab Agency misled Home Office over checks on asylum-seekers." *The Independent*, March 5.

14 Tim McNamara, Carolien Van Den Hazelkamp, and Maaike Verrips, *LADO as a Language Test: Issues of Validity*, Oxford University Press, 2014.

Avi Feldman *(Born in Montréal, Canada) is based in Tel Aviv, Berlin, and Dresden, where he works as a curator and writer. Since 2013, Feldman has been a PhD candidate at The Research Platform for Curatorial and Cross-disciplinary Cultural Studies, Practice-Based Doctoral Programme–a collaboration between the University of Reading (UK) and the Postgraduate Programme in Curating, Zurich University for the Arts (CH). As part of this programme, his thesis focuses on examining contemporary reciprocal relations between the fields of art and law. Feldman's research is supported by ELES - Ernst Ludwig Ehrlich Studienwerk.*

An Interview with Milo Rau
conducted by Avi Feldman

27 August 2015

The Congo Tribunal is a production of director Milo Rau and the International Institute of Political Murder (IIPM) founded by Rau in 2007. The tribunal was divided into two hearings taking place on two continents. The first was held at the Collège Alfajiri in Bukavu, the Democratic Republic of the Congo (the Congo) on 29-31 May 2015, while the second was held at the Sophiensaele Theatre in Berlin, 26-28 June 2015.

This theatre and film project follows the structure of a tribunal as it sets out to investigate the ongoing Congolese Civil Wars, which since 1996 have claimed the lives of about six million people. Recognized by many as one of the bloodiest wars since World War II, the tribunal invited more than sixty witnesses and experts to closely unfold the political, social and, perhaps most importantly, the economic background and causes of this never-ending conflict. Entangled between rebel armies, local and international corporations, NGOs, the World Bank, and the United Nations, the tribunal pinpoints the globalized state of affairs of a conflict too seldom recognized as a global war.

Avi Feldman: Let us begin with how you got involved with The Democratic Republic of the Congo (the Congo).

Milo Rau: That's quite simple. I started with a project entitled *Hate Radio* (2011). It was a staged narrated work that dealt with the Rwandan genocide of 1994 through news broadcasts and racist speeches, but also through pop music and sounds with performers from Rwanda. Then I started in 2010 to travel to the region and learn from close-up about the local conflicts of the Congo and Rwanda. These conflicts have been going on now for more than twenty years as the central government in Kinshasa has lost control of the situation. To simplify the matter—during this time of Congolese civil wars, gold and minerals were discovered, and that's one main reason that the war never stopped. There are way too many people who are profiting from the situation. To sum it up—I went into the project of the *Congo Tri-*

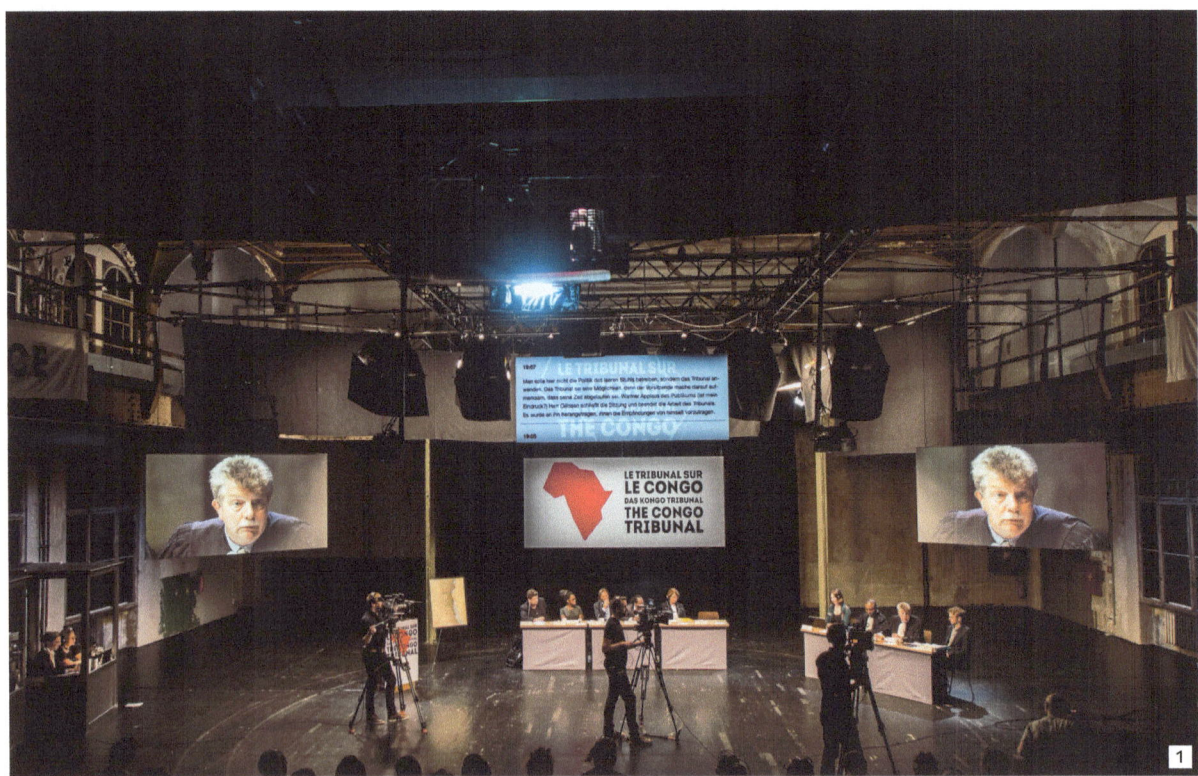

bunal from a local political interest and shifted into a more, let's say, economic globalized interest, or perspective, on the conflict.

AF: The shift was also in form, as while *Hate Radio* was a sort of re-enactment, the tribunal is more of a pre-enactment, and further exploring the legal system.

MR: That's true, but it's important to mention that the steps I took were somewhat different. I didn't go directly from *Hate Radio* to the *Congo Tribunal*. There were stages in between; there was another trial—*The Moscow Trials* (2013)—and this was a kind of open re-enactment, where we kept the form of a free trial dealing with real actors in Russia of the last ten years. The project engaged artists, and state and church representatives in a non-scripted trial with an open ending following the Russian law. Also that year, we made another trial called *The Zurich Trial*. In this work, I created a trial that never happened in Switzerland against the right-wing newspaper dealing with the issue of freedom of speech. It was also, if you want, a pre-enactment.

In the case of the Congo, it was not a Congo Trial but a *Congo Tribunal*, which I think is something very different. In the previous trials, we tried to give arguments of right-wing journalists, or Orthodox activists and so on, the same space as you give the dissidents and to the left-wing press. However, in the *Congo Tribunal*, dealing with an ongoing war and the killings of six million people, I decided not to give the same space to the army and to activists of the region. We were looking into the Congo constitution and the national human rights as resources, but different from previous projects, in the Congo those laws do not really exist at the moment, and if there are laws, no institution implements them. What became more and more clear was that the global economy, and its tremendously acute effects on the Congo, is the issue that needs to take centre stage.

AF: A month before the tribunal in Berlin, you held one in Bukavu–how would you describe the differences between the two?

MR: in Berlin we analyzed the outcomes of the hearings in Bukavu with the help of experts, allowing a more distant level, an analytical approach. In Bukavu it was a tribunal of the people. It was really antagonistic in its nature as government officials were voicing their opinions along survivors giving testimonies of what happened. All this as we were searching for some sort of truth. In Berlin we were asking other questions, spanning from why the UN is failing to bring peace to the region, to questioning the right of global companies working in the Congo to operate as they do, to what we should change in European and international law. So, it was more of an analytical discussion.

Also, now when I am in the process of editing the film with all the documented materials, I am focusing on the Congo part more closely and sometimes I step out as if trying to include footnotes from the Berlin tribunal. This helps to clarify and make the situation better understood by the Western public. After twenty years of civil wars and some one hundred different rebel groups and rapid governmental and institutional changes, it is a hard situation to grasp. I made the Berlin part to show, and this is very important to point out, that the conflicts in the Congo are part of a globalized world while no trial has been held. It needs to be understood as an international war, a world war, not a regional ethnic war as some might wish to think.

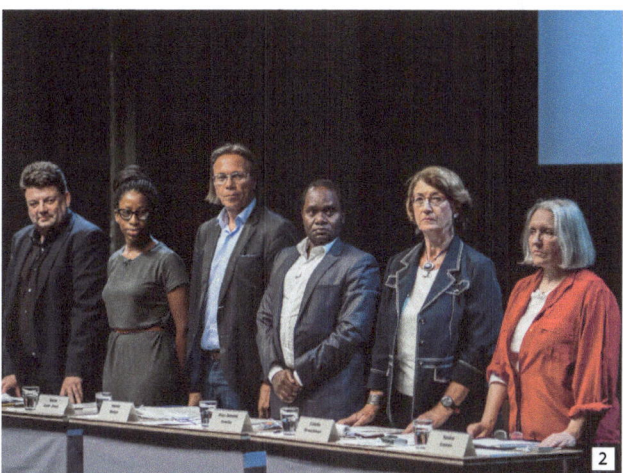

AF: Doing this while exposing the limits of the local and international law? Perhaps while re-thinking it?

MR: The trials I did up to the *Congo Tribunal* were more an idealization of law. It's a utopic law in which I was interested in the search for truth. I was interested in the very simple analysis of what you have to do to tell the story of past trials through a new one. In the earlier trials I worked on, it was a bit of a shock at first when I realized that everybody took their role [seriously] and everybody understood what it meant to search for the truth through law, through a lawsuit, a trial, even if it's fictional.

In the *Congo Tribunal* the situation was different. It is another level of behaviour when dealing with an existing fight among people. I felt a need to expose what lies behind this ongoing conflict and wars, while the tribes themselves deny it. They claim it's a post-conflict situation. I wanted to first show the truth, and secondly to understand what is the meaning of the so-called globalized society. We so often talk about globalization, but to underline the meaning of this term, to have a clear picture of it, is at the very same time extremely difficult. Twenty years of a conflict continuing to go on as if it was some sort of normality. It is even more vivid to me now, when I am editing sixty hours of filmed materials, as all the many different levels of operation and reasoning come out and intertwine.

AF: Mentioning the film—at the beginning of the first day of the tribunal in Berlin you are seen briefly on stage holding a clapperboard. It marks the beginning of the process as well as of its documentation on film.

MR: Yes, that's true.

AF: And in a sense you are the only artist on stage during the whole tribunal, right?

MR: Yes, I'm making the documentary.

AF: Were you thinking of involving other artists as part of the jury, for example, or in other aspects of the tribunal?

MR: There is one other artist whom perhaps you have forgotten—the author and playwright Kathrin Röggla. She is the writer present on stage, and she has a very important part in my opinion. What she is writing is presented live to the audience via a large screen. She is a much known writer, perhaps one of the best of our time to live now in Germany. While the tribunal develops, her role is to write live comments on what she's listening to and witnessing on stage. The audience sees it and reads it as it is happening, and it is also streamed online. This also took place in the tribunal in Bukavu, and in the end this written material will be used by me as part of the script for the upcoming film of the *Congo Tribunal*.

AF: Going back to the stage of the tribunal—was it important for you that the tribunal be held in a theatre? Was it in a theatre in Bukavu as well?

MR: In Congo there were not so many options of where to hold the tribunal. The space where the tribunal took place has some history behind it, but for me the most important aspect is in having a tribunal in the Congo, to have it where the war and conflicts are happening. I perceive it as a problem that the *Vietnam Tribunal* organized by Bertrand Russell (1966) was never made in Vietnam itself. The same goes for many other tribunals such as the *Russell Tribunal on Palestine* (2009), which was not held in Jerusalem, to the *World Tribunal on Iraq* (2003). Perhaps because they were not made by artists, the importance of being at the place itself did not occur to them. This was the reason why we did it first in Bukavu and then in Berlin, and in Berlin every space would have been a good space. It was more about holding the tribunal's sessions in the city of Berlin.

AF: Skipping quickly to the final words made by both tribunals, the one in Berlin seemed to have ended in much more hesitant verdicts.

MR: Yes, I agree, it was much more hesitant in Berlin. The jury found it difficult to give the verdict, as they felt in some cases that they needed more fact-based evidence. It was a long process, going through the whole night, and the jury became more and more hesitant with every hour that passed. There were a lot of questions that the jury was facing which

are hard to answer in only three days; and of course, it is almost impossible to be fully convinced on all matters. I think that the jury gave, at the end, a clear verdict, but at the same time it's more hesitant than the one given in Bukavu. In Bukavu, it was extremely clear. For example, the government and army were found to be totally responsible as it was managed to be proved throughout the tribunal. In Berlin it was less the case.

AF: I also wanted to point out yet a different tribunal—*A Trial Against the Transgressions of the 20th Century*—that was held at the ZKM in Karlsruhe just few weeks after the *Congo Tribunal*.

MR: Yes, I was invited by the ZKM to take part in it, but it was too close to the dates of the *Congo Tribunal*, so I couldn't attend.

AF: Do you feel that there is maybe more of an interest in the art world nowadays in having tribunals?

MR: I think we are in a moment during which artists are making political art that is often not surrealistic, not anarchistic, and not ironic. It's a kind of Jean-Paul Sartre, Albert Camus normal way of putting it. The question for me would be whether they use it as a form of intellectual platform to speak their ideas, or do they want it to function as a platform where things happen not necessarily in the way one would initially expect. If we take the tribunal in Bukavu as an example, we invited survivors along with rebels, and army generals, and we allowed matters to unfold without knowing what might happen and what would come out of this. This is why at first I was not very sure about making a tribunal in Berlin, although now I am happy we did. I did not want it as a space for only repeated argumentations.

AF: What are the next steps for the tribunal beside the release of the film?

MR: We are planning together with ZDF/ARTE to create an Internet platform, which will hopefully allow spreading the message of the tribunal through television and mass media. I think the problem with some projects made today is that very few know about them except you and me and about fifty other curators, and I am not elitist enough to accept that situation.

Captions
1 Setting „The Kongo Tribunal" at Sophiensaele Berlin, Photo: Daniel Seiffert.
2 Chief prosecutor Sylvestre Bisimwa questions Presidential candi-date and expert of the tribunal, Vital Kamerhe during „The Berlin Hearings". Photo: Daniel Seiffert.
3 The jury of „The Berlin Hearings" from the left ot right: Wolfgang Kaleck, Saran Kaba Jones, Harald Welzer, Colette Braeckman, Saskia Sassen. Photo: Daniel Seiffert.
4 Milo Rau during an investigative film-shoot with Congolese soldiers.

Milo Rau *(born 1977) is a Swiss theatre and film director, journalist, essayist, and lecturer. Rau studied sociology, German and Roman studies in Paris, Zurich, and Berlin under Tzvetan Todorov and Pierre Bourdieu, among others. In 2007, Rau founded the theatre and film production company International Institute of Political Murder (IIPM), which he has been running ever since. His productions, campaigns, and films have been invited to some of the biggest national and international festivals, including the Festival d'Avignon, the Berliner Theatertreffen, and the Kunstenfestival Brussels.*

Along the Law
Hila Cohen-Schneiderman

A Question of Freedom

I'm not a religious person, nor even a *traditionalist* (in the Israeli sense of the word). Yet, there is one Jewish holiday that always gets under my skin: *Shavuot*, literally meaning "Weeks" in Hebrew, and also known as *Pentecost* and the *Gift of the Torah*. What is interesting and odd about this feast is that it is the only holiday in the Jewish calendar unbound by a specific date. Instead, it comes with instruction –to be celebrated within fifty days following Passover (during which grain harvesting begins): "Seven weeks shalt thou number unto thee: begin to number the seven weeks from such time as thou beginnest to put the sickle to the corn. And thou shalt keep the feast of weeks unto the LORD." (Deuteronomy 16:9-10, King James Bible)

These instructions create an immediate connection between the two holidays sharing an agricultural bond as a sign for their conceptual relations. Passover is considered to be a formative event that marks, according to the tradition of the Jewish people, flight from slavery (in Egypt) towards their freedom. Redemption, however, did not come easily as they ended up wandering long days in the desert–an unknown territory, which can be defined as a state of cultural vacuum. Allegedly a state and space of absolute freedom, it was also a time of uneasy transition–from enduring harsh slavery to the absence of any newly constructed system. And so the story goes that only after surpassing the immense challenge of being nomadic in a no man's land, only then, were they ready to receive the Torah–the laws and orders of the lord–which they took upon themselves.

Shavuot, in this manner, represents not only the freedom from something–a *Negative Freedom* if to borrow Isaiah Berlin's term[1]–but also the freedom to choose to believe in something. A *Positive Freedom,* which according to Berlin is a set of restricting rules, a constructed system, limitations and borders that people take upon themselves as individuals and as a community. This mythical tale strongly reveals that in its core law is a religious, ideological, and even messianic enterprise. It requires faith, and it requires obedience. But, as religion creates the agnostic, law invites insubordination.

What is, then, the law when considered in this schema? We could define it as a decree formulated by society and entrusted to different enforcing entities. We could break down control into a myriad of actions including planning, registration, setting boundaries, and enforcing them. To make an analogy using physical terms– it can be identified with the contraction of muscles versus relaxing them (I will return soon once again to the body as a useful metaphor). Usually, when there is a law, obedience is required, and there is no more need for judgment–just identification followed by adaptation. Only creative, or perhaps criminal minds, find ways to get around it, seeking to push its boundaries. Artists, too, tend to delineate or challenge the limits of the law, and for the most part have a troubled relationship with it.

We are born into sets of laws that we usually accept with no question or doubt—it could be the legal system of our state, or the inner codex of our family; schools are considered yet another system to which we are assigned to without a choice. In what could be considered a contrast, our workplace is the first system we choose as responsible adults to be engaged in and with as we take upon ourselves its codex of "beliefs". Some establish their own seemingly independent and freelance environment—for not all people deal well with institutions or authority.

The question of the codex of the "workplace" gets complicated when observing the art field: first and foremost, since artists are mostly in a precarious position, not working as an official part of the institutions but within them; and second, since many artists have an ambivalent relation to the concept of border as a signifier of what always needs to be questioned. Good examples for this inquiry can be found in Yoko Ono's work *Cut Piece* (1965), a performance questioning the ethics of the viewer; the Chris Burden performance *Shoot* (1971), in which he had himself get shot[2]; the work of Ai Weiwei, who publicly criticizes the Chinese government's stance on democracy and human rights, and due to his activities was arrested in 2011 and his passport confiscated; the Yes Men's actions against giant corporations[3]; and Jill Magid's residency at the Dutch secret service[4], to mention just a few. In this sense, curators are quite intriguing in their working habits, often times situated along the borders and crossing inside and outside, working with institutions on a regular basis as insiders—as an integral part of the system, or as outsiders—as guests who cooperate with an institution based on a project or an exhibition. Curators, so it seems, know how to play by the rules without the antagonism that bureaucratic infrastructures usually give rise to among artists. Thinking again about the two dichotomous concepts of *Positive* and *Negative Freedom* by Berlin, curators can be perceived as working in the grey zone between the two, while conducting with their own body contradictory motions of agreement and refusal.

However, playing by someone else's rules may be rather frustrating, and therefore, carries within it the seed of a future resistance. People tend to want to shape systems, not just to participate in them, as curator and theoretician Nora Sternfeld suggests in her article, "Playing by the Rules of the Game." Sternfeld points out that this exclusion is the exact problem with the museum's and artistic aspirations to generate public participation: "After all, a democratic understanding of participation entails being able to participate in the decision-making process that determines the conditions of participation, decision-making and representation. Participation is not simply about joining the game, it is also about having the possibility to question the rules of the game [...]. And, when understood in this way, participation indeed makes a difference."[5]

Sternfeld is part of a greater and important area of institutional scholarship concerned with critical management (CMS) flourishing since the 1990s, and which is still vastly relevant in current times[6]. Not for nothing, an earlier issue of *On-Curating* (Issue 21, January 2014) was dedicated to revisiting the thought and practice of New-Institutionalism influenced by this wave. Many are seeking the ability to create new institutions, or to bring new management methodologies into old ones, while trying to address not only the institutional goals, but also the well-being of the humans working within them. Sternfeld herself devoted the last couple of years to developing an institutional platform that remains experimental and constantly examines its contours. Operating under the title *Trafo. K*[7], she has co-established an office located in Vienna dedicated to art education and to the creation of critical knowledge.

And yet, most of us are working in institutions (artistic or not), where we are not the ones who conduct or outline the institution's vision and/or guidelines. Despite this, we try to leave our mark, or to lead in a direction in which we believe. Most of us have to negotiate quite intensely between the policies of the institution in which we work or with which we cooperate and the set of beliefs and desires that we hold as individuals. All too often this ends up in walking on a tightrope between maintaining independence of thoughts and actions and carrying out our duties. With this notion kept in mind, a different survival strategy is needed in order to survive these incorporated tensions.

Many curators live according to this tension on a daily basis, addressing it as a site of interest. I wish to suggest once again the use of the human body as a metaphor assisting me to further the discussion. It is not by chance that the term "body" (Guf=גוף) in Hebrew refers not only to the human physiological structure, but also to the institutional one. The etymology of "organ" and "organization" could be a good equivalent in English, thinking from within the lines taken from the First Letter of Paul to the Corinthians: "Just as a body, though one, has many parts, but all its many parts form one body, so it is with Christ. [...] Now you are the body of Christ, and each one of you is a part of it." (1 Cor. 12:12-27)[8]

Talking about a "body with organs" in the current state of affairs—when the world is being led by powerful and invisible forces, mainly economic, that are shaping our global environment in ways we cannot even begin to perceive let alone resist—is rather challenging. Recent films, such as *Citizenfour*, which tells the story of Edward Snowden, or *The Mona Lisa Curse*, outlining how art became subordinated to the money-making and capitalist market economics on the other, successfully illustrate how knowing more about this mechanism does not assist much in resisting it. Nevertheless, institutions are physical structures in which invisible power receives its clothes, its body—this happens through the daily presence of people working inside of them.

One of the most important notions of the body is to stay flexible. It's a necessity in order to keep free movement—in body and in mind. Stretching the borders or expanding them is one of the most important roles of art and artistic thought in our society, as they are the ones capable of challenging the way we think alongside theoreticians, scientists, and scholars. They are at the site of institutional tension, while working with the tension itself as a material[9]. To provide an example of the potential and problems of this inner bond, I would like to refer to the City Artist in Residency platform.

Trojan Horses?

The City Artist in Residency became a mythological project that began as an independent initiative by the artist Mierle Laderman Ukeles and the NYC Department of Sanitation towards the end of the 1960s. No curator was involved, or was credited, for this celestial marriage holding on now for more than forty years. What is so incredible about this match was that the critical force of the artist was not aimed toward the institution, but towards the general public in a deeply constructive way. Laderman Ukeles aspired to open the public's eyes to the invisible daily work done for the well-being of the city by the department's diligent and under-appreciated workers. The heavenly match can also be attributed to the fact that Laderman Ukeles dealt simultaneously with the unseen quality of maintenance demanded by her as a young mother in the scope of her own living space. She

articulated it through artistic practice (performances of cleaning museums, for instance), and in her published *Maintenance Manifesto*:

> B. Two basic systems: Development and Maintenance. The sourball of every revolution: after the revolution, who's going to pick up the garbage on Monday morning?
>
> Development: pure individual creation; the new; change; progress; advance; excitement; flight or fleeing.
>
> Maintenance: keep the dust off the pure individual creation; preserve the new; sustain the change; protect progress; defend and prolong the advance; renew the excitement; repeat the flight;
>
> show your work—show it again
> keep the contemporaryartmuseum groovy
> keep the home fires burning
>
> Development systems are partial feedback systems with major room for change.
>
> Maintenance systems are direct feedback systems with little room for alteration.
> (from: Mierle Laderman Ukeles, MANIFESTO FOR MAINTENANCE ART 1969! Proposal for an Exhibition "CARE")

One might say that the artist and the sanitation department shared the same set of values and interests. No one had to pay Laderman Ukeles in order for her to be the resident; it was based on her own free will and inner motivation to act. She worked with what she had—the equipment and resources of the department and the employees. No curator stood in the middle of this engagement.

Since then, greater attention has been directed towards the municipal system as a potential space for artistic collaboration. For example, in 2006 the Public Art Saint Paul organization based in the city of Saint Paul (USA) initiated the *City Artist Program*. Today the program operates with two artists in residency—Marcus Young and Amanda Lovelee. The two do not work within a specific department, but are involved in what can be described as a general view of the municipality. As indicated on the program's website: "Artists advise on major city initiatives and lead their own artistic and curatorial projects and have dedicated workspace within the Department of Public Works so they can freely collaborate across city agencies."[10] The latest residency joining this shift was initiated—certainly not by chance—by Tom Finkelpearl, the former director of Queens Museum and the new Commissioner of the New York City Department of Cultural Affairs. Finkelpearl holds a long proven record of supporting socially engaged art. Recently, in collaboration with the Mayor's Office of Immigrant Affairs (MOVA), they created a new and official artist-in-residence. The artist Tania Bruguera, initiator of the project *Immigrant Movement International*, was chosen for this position.

Nowadays, a reluctant number of artists are able or willing to make the sort of independent commitment Laderman Ukeles took upon herself, nor do many municipalities open their gates and invite artists to be their residents. Curators who are interested in these engagements are due to negotiate with municipalities to obtain permissions for artists to work as guests within their facilities. They also

need to raise money in order to pay monthly salaries to the artists, since they are the ones inviting the artists to take a residency in the first place. Moreover, when a curator is the initiator, and not the artist, a whole new set of conflicts arises. That was the case with *The City Artist Residency* at Jerusalem Municipality, initiated by the urban planner and curator Gilly Karjevsky, for which I served as a co-curator.[11]

Herewith, I will give only one example of the complexity stirred during the residency of artist Ruti Sela in the Municipality's legal department (2012). Jerusalem, as it might be known to some, is a barrel bomb of a city with flammable political ticking charges ready to explode at any given moment[12]. Sela, for her part, is known as an artist operating always in close friction with the law. Works like the video trilogy *Beyond Guilt* (2003-2005), which was made in collaboration with Maayan Amir[13], and their current collaboration on *Exterritory Project*[14], gave her this justified reputation. Precisely for this reason, Sela was interested in being the legal department's resident, turning the laws themselves into her subject matter. In that case, harmony wasn't expected from her residency.

The head of the legal department had exhibited an honest desire to host an artist in his midst; but he had a very specific artist in mind—it needed to be a painter, perhaps a contemporary version of Honoré Daumier, who used to draw sketches in the courts of law. In their introductory talk Sela, a video artist, proclaimed herself to be a painter. This was not a total lie as she did commence her art studies as a painter, but had long since abandoned painting in favor of video art. She asked for permission to record her meetings and conversations with the department workers, and he approved as long as their statements were not hand written. In the video work, *For the Record* (2013), that documented her residency, we see Sela talking with lawyers and getting them to talk about various legal matters while painting their portraits in "Bad Painting" style. It was evident that Sela was seeking to understand how the urban system operates. She was interested in the cracks and contradictions within the system itself, alongside the loopholes through which one could promote a different agenda. Sela's engagement even amounted to proposing a bill or an amendment that she herself formulated, but given it was only a short-term pilot program; the main outcome remained as expected—a video work based on the different conversations she held, including her own confession to the head of department. When asked about her perception of the project, she answers:

"I entered a territory that I couldn't have entered otherwise."
"Is it challenging, as an artist?" he asks.
"Very much," she answers.
"It's also a totally different field, almost the opposite. To me being an artist means wanting to be beyond the law or not to believe that there is a law. You know that the law is fictitious; it's made up. And here [in the department] you believe in it."

"Yes" he answers, "We safeguard the fiction. Law is artificial. Man-made."
The conversation ends in silence as certain awkwardness remains in the air.
As co-curator of the project I often times asked myself—did we destroy his trust in artists? Will he, once again agree, to host another artist? The aspiration to integrate artists into municipal departments stems from the desire to push the boundaries of artistic actions and to expand the art field into wider territories, echoing among others the spirit of institutional critique that began to rise in the 1960s. This notion was also reflected in *The Artist Placement Group (APG)*, placing artists in commercial companies and in government departments[15]. But this aspiration, more than producing concrete extensions, reveals fundamental limitations—as

long as artists and curators do not occupy a true role in shaping institutions it remains more immediate for them to resist or utilize the institution than to operate within its framework. If that is the case, the question is not related only to the transgressing of the law, nor only to testing its limits, but rather to the actual ability to formulate it.

The term "subversive" was widely used in the art field regarding the aspiration to change the system, mainly by criticism, dismantling mostly by using the logic of the Trojan horse. But, regardless of some heroic declarations, existing systems are still holding on strong, while subversive attempts do not have the real ability to shake the ground on which they are based. Perhaps since there is no longer a territory "outside" of the system, the possibility of letting go of the fantasies of deconstructing it can also be considered. If we are a part of the system, another option unfolds—that of changing it from within. In this case, our actions take place within the blind spots of empire. They are becoming part of it as they expand its borders and change its nature slowly, but surely. It may not be a dramatic change, and definitely not an orgasmic revolution, but in the end the abolition of the dichotomy of inside-outside is empowering for the individual freedom to act, in mind and in body.

The Exhibition as a Small-Scale Political System (Back to the Art World)

In what may seem at first glance in defiance of the above, there is one position where I believe that the curator is omnipotent or powerful (but not necessarily forceful). The group exhibition, in the manner I wish to further explore, holds the potential to be such a space—one to be defined as a "temporary autonomous zone," to use the words of anarchist author Peter Lamborn Wilson known by his pseudonym Hakim Bey. The work process on a group show could become an area of freedom within the system; too small for the great empire to be interested in, it is where the curator can establish her own working rules.

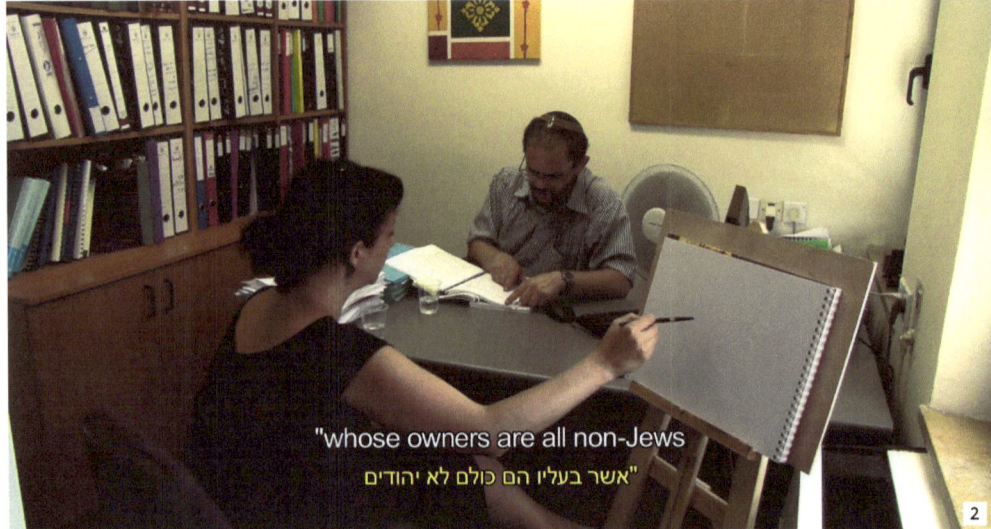

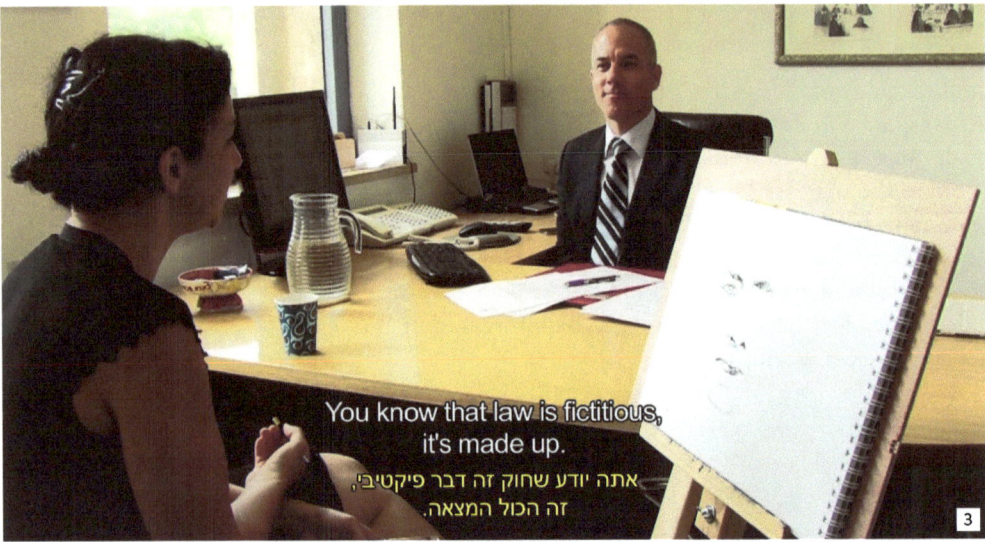

In the last three years, I have been practicing this thinking with a group of eleven Israeli artists, trying to perceive the potential of a collaborative work process while establishing our small-scale political system. In July 2015, our first group show took place at the Petach Tikva Museum of Art, entitled *The Crystal Palace and The Temple of Doom*[16].

Except for the thematic investigation that was related to the city space and political organization, we chose to investigate this theme not only through the artworks, but also through our inner work process. This process offered a different hierarchy to the one that usually shapes group exhibitions, at the centre of which stands the curator—selecting works and artists to his or her liking, and arranging them in relations of power and meaning. As time went by, I realized that my role as a curator was being re-examined in every single one of its parameters. From the very start, I gave up all those attributes that regularly fall under the responsibility of the curator: approving the works, writing an elucidating text, directing the installation of the works in the space. The focus of the curatorial practice was no longer on the exhibition, but rather on the constant maintenance of the working and thinking process.

The model developed is not founded on the hegemony of one person and not of the collective. Instead, it is shaped by individuals who are willing to acknowledge that their individual and supposedly autonomous practice has an inevitable influence on others around them, as well as on their physical environment. In other words, we create the environment and the space, which affect us in a reciprocal feedback of sorts. It is similar to the way an architect's plan of a building influences the well-being of its inhabitants, or when an artist influences the viewer with his or her artwork. The mundane practical questions—such as how the light emanating from one's projector will illuminate another's artwork, if the sound of one work will disrupt the work next to it, and what is the conceptual relationship between the art objects in the space—all shifted course and were to be asked through an ideological substantive prism. Hence, what matters is not only the artistic object, but also the political conditions in which it was produced; not just the objects but also the gaps and interfaces between them, those usually left to the attentive care of the curator, or those that fall between the cracks. And even prior to that—the exhibition simply reflects how relations between artists create relations between objects; or in other words—that one cannot detach the exhibition from the power relations that created it.

Notes
1 Isaiah Berlin, *Four Essays on Liberty*, Oxford University Press, 1969.
2 cf. https://www.youtube.com/watch?v=JE5u3ThYyl4.
3 cf. http://theyesmen.org.
4 cf. http://jillmagid.paas.webslice.eu/books/becoming-tarden.
5 Nora Sternfeld, "Playing by the Rules of the Game," *CuMMA Papers* No. 1, 2013.
6 cf. http://www.criticalmanagement.org.
7 cf. http://www.trafo-k.at/en.
8 And many thanks to Nicola Terzzi, who brought my attention to this reference.
9 It is important to note that the different case studies serve as a model to be amplified in similar territories; however, the specific examples are not to be considered as work models since they are the fruit of an extremely human one time-situation of an artistic endeavor.
10 cf. http://publicartstpaul.org/cityartist.
11 For further reading: אמנית העיר: חוברת מחקר, ירושלים 2102, עורכות: גילי גרז'בסקי, הילה כהן שניידרמן, הוצאת עונת התרבות, פסטיבל מתחת להר
12 For further reading, see: Naina Bajekal. 2015. "Six Reasons Why Jerusalem's Old City Has Again Become the Focus of the Israeli-Palestinian Conflict," *Time Magazine*, September 16. [http://time.com/3595090/jerusalem-old-city-conflict/]; 2015. Eric Thorp. "Jerusalem Season of Culture: In House Festival," *FAD Magazine,* August 14.
13 cf. http://www.contemporaryartgallery.ca/exhibitions/ruti-sela-maayan-amir-beyond-guilt-the-trilogy.
14 cf. https://exterritory.wordpress.com/initiators.
15 For further reading on examples of contracts signed with companies: http://www.stuartbrisley.com/pages/29/70s/Text/The_Artist_and_Artist_Placement_Group___Studio_International/page:15; Information about the group activity on the Tate Museum's website: http://www2.tate.org.uk/artistplacementgroup/default.htm.
16 cf. http://www.petachtikvamuseum.com/en/Exhibitions.aspx?eid=3519

Captions
1,2,3 Ruti Sela, *For the Record,* 2013, 18:00 min. (video)
4 Hilla Toony Navok and Eden Bannet installation view from the exhibition *The Crystal Palace and The Temple of Doom,* curated by Hila Cohen-Schneiderman, Petach Tikva Museum of Art; Photo by Avi Levi, 2015
5 *The Crystal Palace and The Temple of Doom*, general installation view. Curated by Hila Cohen-Schneiderman, Petach Tikva Museum of Art; Photo by Avi Levi, 2015
6 Eden Bannet and Tchelet Ram from the exhibition *The Crystal Palace and The Temple of Doom,* Curator Hila Cohen-Schneiderman, Petach Tikva Museum of Art; photo by Avi Levi, 2015

Hila Cohen-Schneiderman is a curator at the Petach Tikva Museum of Art, and a curator at CAiR - Program for artists' residencies in municipal departments. She is a graduate of the "Revivim: Honors Program for The Training of Jewish Studies Teachers" and holds an MA in Hebrew Literature from the Hebrew University of Jerusalem. From 2010-11, she acted as chief curator of the Spaceship Gallery at Hayarkon 70 social complex, Tel-Aviv.

The Sirens' Song: Speech and Space in the Courthouse*
Avigdor Feldman

The law averts its face and returns to the shadows the instant one looks at it; when one tries to hear its words, what one catches is a song that is no more than the fatal promise of a future song. (Foucault and Blanchot 1987, 41) Like sailing, gardening, politics, and poetry, law and ethnography are crafts of place: they work by the light of local knowledge. (Geertz 1983, 165)

"It's a remarkable piece of apparatus," said the officer to the explorer. ... (Kafka, "In the Penal Colony," trans. Willa and Edwin Muir, in Franz Kafka, *The Complete Stories,* ed. Nahum N. Glatzer [New York: Schocken, 1971], p. 140)

Law is composed of space and speech. There is a link between the verdict and the courtroom, between the seat of justice and the legal pleading. Space and speech are complementary, cooperating in a strategy to separate and isolate the judges' knowledge from the knowledge possessed by the defendant and from that of the third party–those who are not yet either accused or judges. The seat of justice is a system of doors, corridors, chambers, and horizontal and vertical sections that channel legal speech and produce its vowels and consonants. The legal space is the sound box of legal speech.

One function of the legal space is to swallow up the elements of power and will that dominate legal speech and to stifle the awareness that the court's authority to punish and issue verdicts is a license for violence, penetration, rape, negation of the body. Legal speech does this by means of rules that seem at first glance to have something else in mind–perfecting the law's ability to distinguish truth from falsehood–but that in fact block the channels of communication between the several communities of legal discourse, obstructing the exchange of information between judges and defendants and among the defendants themselves.

The prohibition of hearsay testimony is an example of an effective barrier to communication between the different legal communities. On the surface, it is intended to guard the court against evidence that is not trustworthy; in practice, though, it dilutes the world of speech, gossip, and the knowledge conveyed by word of mouth, because the trial is a matter of luck, and the judge is interested in the worst for the defendant. The rule against hearsay testimony silences all those who are not in the first circle that surrounds the court and forbids others to quote them or attribute any opinions or statements to them. This devalues speech that, with regard to its status in the legal space and hierarchy, is "behind the back." The result is a judicial face that has no back; or, more precisely, a back and belly that are joined and keep switching places. The legal space supports this theoretical physiognomy of the law. The courtroom is structured so that only the judge's front side is illuminated. The door between the judge's chambers and the courtroom channels judges' entrances and exits so that one never sees their back. The essential attribute of this elimination of the back is revealed by the little dance that attorneys perform when they leave the courtroom, their face always towards the bench and their feet cautiously shuffling backwards towards the door, until they pass through it.

The rule against hearsay evidence allows a voice only to those in the first circle around the court, which contains those whom the court can summon and dismiss, order them to speak, or silence them with another order. This allows it to control of the world of speech and writing that extends beyond it. The system that is essential for controlling speech, with no taint of secondhand information or rumors, is rather simple. Thanks to the rule against hearsay, the voice of subversive speech groups located on the margins of the world of law, with their wonderful and terrible stories about what takes place in the courtroom and their gossip about judges, prisons, and jails never reaches our ears.

The acoustic insulation created by the rules of relevance, laws of evidence, and inadmissibility of hearsay supplements the walls, corridors, and internal

division of the physical space. Their interconnections must not be seen as mutual reinforcement and nothing more; the legal space is home to an array of images and world pictures that are projected onto legal speech and reflected back from it onto legal speech. This is a feedback process involving pictures of the law, compounded of air and matter, of the legal space and legal speech.

Another way to control legal speech involves certain mimetic conventions, notably the use (to which we shall return below) of a rhetoric that moves along the axis of metonymy rather than that of metaphor, as well as clear distinctions between the absurd and the sublime, between the superficial and the profound, between the banal and the unique, between the traditional and the new. The preservation of the purity and boundaries of speech is typical of the discourse of power and sex, which are especially apt to camouflage themselves, because control of speech is one of the main goals of the power relations that prevail in law.

In what follows I shall be looking for the invisible links between the legal space and the legal text and at their common effort to create a vocabulary, gestures, and rules of conversion and concealment. I want to see law that does not retreat into the shadows, to listen to the sirens' song without yielding to the total seduction that swallows up the words and the music. I do this on the margins of the law, where the hidden link between space and speech is weaker. Objects that have been forgotten and now sit alongside texts on the fringes of the legal canon are swept there, standing out in their deviance, and consequently subversive and plotting evil. I will look closely at the courthouse and plug my ears against the indictments, the tears of the murder victims, the anger of those who have been robbed and the terror of those who were raped. Instead of sitting in the courtroom, exposed to the judges' glare, I will steal away to the suspended causeways that connect the judges' chambers to the stairwells and the judges' lounge and restroom; instead of reading the verdicts published in the bound volumes I will open only the first pages, with their ostensibly neutral list of the litigants' names. My motivation here is to elude the ceaseless clamor of chewing on precedents. I will tear out a random page of a verdict and expose it to diseases, assault by errors, word combinations, and name switches, all of which reveal the true shallowness of legal language, a continuum between front and rear, between belly and back that keep interchanging their positions. I will review a legal lexicon, a remote, mendacious, and foolish book, in search of the legal clichés there. In another section I will try to analyze law against the grain, across its main rhetorical axis of metonymy and along the axis of metaphor instead. Scanning the law against the fibers partially unravels the rigidities of legal speech and makes it possible to create an alternative discourse at the very centre of the law.

This is effectively disinterring dead horses. The Aztecs of Mexico believed that the conquistadors from across the sea were gods and immortal. The Spaniards, having become aware of this belief, did what they could to foster and exploit it. When Cortés learned that the Aztecs thought that his horses, too, were divine, he had the mounts killed in a battle buried during the next night, so that the locals would not see their carcasses on the field and begin to have doubts about the invaders' divinity. Legal texts are strewn with the buried carcasses of dead horses, the secrets of chance and contingency, and the illogical violence of the law.

The Seat of Justice: The Tel Aviv Courthouse

Legal interpretive acts signal and occasion the imposition of violence upon others: A judge articulates her understanding of a text, and as a result, somebody loses his freedom, his property, his children, even his life. (Cover 1986, 1601)

The court interprets the law while also inflicting violence and punishment. These two domains of activity create opposing fields of knowledge, forged by the interaction of speech with stubborn space and matter. Interpretation joins together, packages, and creates meaning. Punishment and pain take apart and destroy. Interpretation is a holistic, liberal, cognitive, and beneficial act of civilization; punishment and pain touch levels of meaning that are opposed to civilization, the deep knowledge that the world is arbitrary and contingent. Pain leads to questions about the relationship between the body and the soul, between social values and the inner emptiness that gapes open when sentence is pronounced. The structure of the courthouse zealously preserves the division between these opposed fields of knowledge. The courthouse is a punishment machine that transmits pain from the judge to the defendant. Attorneys, the public, relatives, and police officers are all part of the transmission mechanism, serving as the gears and flywheels of a complex machine. They guarantee that the pain will

be transmitted in one direction only, that the pain that goes down in the elevator packed with prisoners will not return to the courtroom in bloody clothes, wild and threatening. The inner architecture of the Hall of Justice in Tel Aviv, with its hidden recesses, creates and operates the punishment system that begins with an interpretive act and concludes with annihilating violence. The Tel Aviv Hall of Justice, seat of the district courts, magistrate's courts, and other lesser courts (including traffic court and small-claims court), as well as the registrars' offices, the holding cells, and the bailiff's office, floats there on Weizmann Street like an iceberg in the North Sea, one-third visible and two-thirds sunken and folded into itself. The visible sections are the public areas, the entrance foyer, the corridors, the staircases, the various secretaries' offices. To enter the public areas you use the main entrance on Weizmann Street, which serves the public at large, relatives, litigants who are not in detention, and attorneys. The second third, hidden away, is the "Forbidden City" of the judges, into which they sneak every morning through a small door in the building's northern façade on J. D. Berkowitz Street. The small door is opened by the judges' key and locks itself behind them. Having entered the Forbidden City, judges are isolated from the rest of the building. They have special elevators and internal staircases to convey them to their chambers and thence into the courtroom, through the door behind the bench. Within the courtroom there is no passage from the bench into the room itself.

Most of the Forbidden City is suspended in midair. Only the judges' chambers are on the same level as the public areas. When judges want to go somewhere in the Forbidden City, they climb several steps from their chambers and enter a network of narrow causeways that float in the space between the floors. These hanging galleries lead to the lavatories reserved exclusively for judges, to their lounge on the first floor, to their private elevators and stairwell. The suspended causeways are hidden from public view, bordered by a parapet that leaves a narrow slit just above the floor. When a weary litigant raises his eyes heavenward, in despair, he beholds a vision: a pair of legs walking in midair, proudly supporting an invisible judge as she makes her way to the lavatory and lounge in the Forbidden City. From the public areas, then, justice is faceless but wears black shoes. This is actually quite logical, because in the courtroom only the judge's head and upper body show above the bench; but now litigants can use their imagination, sharpened during the course of the interminable trial, to connect the feet they see on the causeway with the head known from the courtroom and produce a judge who is almost complete. But no matter how the parts are assembled, no matter the angle, about a fifth of the judge will still be missing—the plane where the legs, moving forward resolutely, turn into the static head that floats above the robes—the bodily zones of passion and passivity. This part remains invisible, so that litigants can take it to be the hidden seat of the supreme judicial wisdom. The segmentation of judges in the courthouse is a spatial manifestation of their absence from the judicial process as an entity with a biography. One of the sharpest contradictions between judges' knowledge and defendants' perceptions is expressed here. Defendants (and the public at large) attribute their bitter fate or good fortune at the end of the process to the judge's personality—whether the general judicial disposition or that of the chance occupant of the bench on the day of the trial—to the judge's good mood or transient irritation, to his personal circumstances, family ties, or attitude towards a particular class. None of this is to be found in verdicts. A proposal to analyze some verdict as a function of the judge's personality would be taken as contempt of court. Character witnesses and psychologists are frequently summoned to testify about the defendant's soul, but they are not available to testify about a judge whose ruling we want to evaluate or interpret. In every other intellectual field, scrutiny of the creator is deemed a legitimate matter for exegesis; but this is sacrilege when it comes to the law. The "scientific" aspect of the law rejects any "ideological" examination of judges' worldview or any gossipy or popular study of some judge's boorishness or cordial personality. The contents of law journals reveal the extent to which the elimination of the judges is a "scientific" practice. A systematic survey of the legal periodicals of the Israel Bar Association, Tel Aviv University, and the Hebrew University uncovers an intellectual conspiracy to make the judges vanish from the judicial process, a sort of organized body-snatching. All cooperate to eliminate the judges' physical, historical, and psychological lives. I have never encountered a single article devoted to some aspect of the judge as a subject, as a social construct, as a person, as a unit of meaning. In this way, the law has reached a blissful state of authorial concealment. Judges are totally transparent in the judicial process. Law journals write about judges when they retire or die. Only then, after they leave the arena that employs some magic power to protect them by rendering them invisible, are judges returned to their physical bodies.

The American judge John T. Noonan wrote about the disappearance of the judge's person and body from the judicial process in his book *Persons and*

Masks of the Law (1977). He associates the judges' vanishing act with the disappearance of the human body from the legal arena, a deliberate hocus pocus that makes it possible for judges to employ invasive and violent methods against abstract legal entities. In Noonan's opinion, it was this suppression of the human body that enabled slavery to persist in the United States for centuries with no challenge or astonishment, incorporated into a liberal legal system and a constitution that is more solicitous of civil rights than any other. The slave, bodiless and faceless, had no existence in the law as an independent entity, but only as chattel. He was swallowed up by the legal institution of private property, leaving no trace of his individual passage. An assault on the principle of slavery was tantamount to an attack on the fundamental right to property. The United States Supreme Court overturned legislation that automatically emancipated a slave brought to a free state by his master. In an opinion signed by the Chief Justice himself, the court ruled that a law that deprived an American citizen of his liberty or property only because he travelled to some territory in the United States, or brought his property with him, was unconstitutional, because it deprived him of his property without due process of law.

It was only after slaves emerged from the status of private property that they fell into the judicial line of sight. Slavery is possible, writes Noonan, in a legal system that accepts Hans Kelsen's definition that, for the law, the natural physical person is no more than the "personification of a complex of legal norms." Only the ontological status of the human body as an entity that cannot be reduced, concealed, absorbed, or exchanged keeps it from being swallowed up into the entrails of other legal concepts that roam the arena of law like hungry sharks. An Israeli instance of a departure from the special ontological status of the human body in the law is found in the report of the State Commission of Inquiry into the Interrogation Methods Employed by the General Security Service for those suspected of terrorist activity (the Landau Report). The license it granted interrogators to employ "moderate physical pressure" in the name of security swallows up the human body into the belly of the powerful legal institution of "state security." But what is sauce for litigants is sauce for judges as well. Their bodies' disappearance from the judicial process distorts the legal arena just as much as the disappearance of litigants' bodies. Peter Gabel, one of the leading lights of the critical legal studies movement, has written about the judge's disembodiment. He juxtaposes the posture of the judge sitting on the bench with that of a soccer goalie with her repertoire of moves:

> In her play the goalie is present in her body, and her mind and body are relatively unified in the sense that she lives her project as a goaltender through the coordinated "praxis" of her movements. In light of the weight and poise of her presence, it would be difficult to casually push her backward.
>
> Contrast the physical presence of a judge. He sits on an elevated platform, his body almost entirely concealed by a black robe. His movements are usually minimal and narrowly functional, involving mainly the head and the hands. We could say that *his being is in his head* and withdrawn from his body. [...] In light of this absence of bodily presence, if he were standing, it would be very easy to push him off balance with a slight push. (Gabel 1989)

It is doubtful whether the judge would be able to get back to his feet. Litigants are well aware of this. The judge's physical weakness hovers in the courtroom like a defendant's wet dream.

The third third of the courthouse, too, is hidden from view: this is the Netherworld, the kingdom of the prisoners transported to the building in closed vans, brought there from the detention centers in Abu Kabir and Ramle and the interrogation cells of the General Security Service. The vans enter through a large electric gate on Berkowitz Street and pull up in the lot on the other side of the now-closed gate. The prisoners climb out of the van, shackled to one another, isolated from the outside world, isolated from the passions that induced them to commit their crimes. They belong to that vast wandering tribe of transgressors, the chain gang; like their counterparts of the nineteenth century, the prisoner's regular mode of daily life is a constant journey. They spend most of their time on the move, from the police station where they are interrogated to the lockup, and from there to the courthouse and its Netherworld – which, like the Forbidden City, is a separate realm concealed within the walls of the Hall of Justice. The chain gang's constant movement is not interrupted once they reach the courthouse. In armored elevators, where a metal screen divides the prisoners from their police escorts, they are transported from the fetid cages in the basement to one of the courtrooms. Prisoners' continuous cycle from cell up to courtroom, there to be tried, lectured, punished, and then

back down to the police van that returns them to the lockup or prison, is the vital fluid pulsing through the courthouse, or the steam that flows in the punishment machine and never halts for even a single day.

These three regions of the courthouse are separate from one another; the portals between them are almost invisible, often hidden by heavy furniture that has not been moved in a long time. The three different communities that inhabit this building could easily be unaware of the others' existence. The judges might consider the rumor that somewhere between its walls lies the Netherworld, with red-eyed, crimson-garbed residents who emanate a putrid odor, is a despicable fiction, a fabrication meant to discredit them. The prisoners, too, might nod with compassion at one of their number who claimed that hovering above them is the Forbidden City, with paths traversed by headless justice—were it not that judges and prisoners meet at least once in their lives, in the courtroom, which is the crossroads where all the regions meet.

There is no fourth kingdom in the courthouse, one that would be the realization and embodiment of acquittal, a sort of Paradise to counter balance the Netherworld, to which those found innocent would be taken. Just as, having been pronounced guilty, the criminal is led off by guards to the basement and then to prison, liberators would enter the courtroom at the moment of acquittal, strike off the defendant's manacles, and lead him to the fourth kingdom hidden within its walls, the realm of innocence. A formal space of innocence would be a tangible sign of the verdict of acquittal. The liberators, like the jailers, would almost float across the courtroom, summoned for their mission of emancipation in an adjacent courtroom.

The courthouse is the stage for at least two experiences that are polar antitheses. Robert Cover described the opposition between the judge and defendant as follows: "The perpetrator and victim of organized violence will undergo achingly disparate significant experiences. For the perpetrator, the pain and fear are remote, unreal, and largely unshared. They are, therefore, almost never made a part of the interpretive artifact, such as the judicial opinion. On the other hand, for those who impose the violence the justification is important, real and carefully cultivated. Conversely, for the victim, the justification for the violence recedes in reality and significant in proportion to the overwhelming reality of the pain and fair that is suffered" (Cover 1986, 1629).

The judge interprets the law by applying cultural methods that create meaning: analogy, contrast, deduction, induction. Judges create a genealogy of events, a happy family of elements connected to a rich infrastructure of meaning. The defendant, facing them, experiences pain that destroys meaning. Pain, unlike interpretation, produces absolute ignorance; bounds are erased, families of meaning break down, blood relations, friendship, and love lose the intimacy that characterized life before the trial. This is an alternative knowledge that is discriminated against and persecuted, preserved by small communities that have no control over the means of representation. As Elaine Scarry put it, "The intense pain [...] destroys a person's self and world, a destruction experienced spatially as either the contraction of the universe down to the immediate vicinity of the body or as the body swelling to fill the entire universe" (Scarry 1981, 35).

Attorneys frequently observe that immediately after a verdict that condemns the defendant to a long prison term, he remains seated in the dock, dazed and mute, isolated from his social context, outside his family, unaware of the sentence. He is powerless to extract meaning from the words just addressed to him from the bench. He does not know that the trial is over. The judge has already left the courtroom and the defendant stares in confusion at his lawyer: "What happened?"

The main function of the courthouse is to give tangible form to the separation and isolation of knowledge that interprets and gives meaning from the subversive knowledge that verdicts create absolute ignorance, that the judge and the defendant belong to hostile communities that operate on the basis of antithetical principles. This is why its architecture insulates judges from the defendants' knowledge that judges are violent men who deal out death and pain, who rather than creating law and meaning in fact kill meaning.

No one really rules the Hall of Justice. True control of its space would imply unlimited access to all parts of the building. The Hall of Justice is a congeries of spaces and cells, each of which offers sanctuary and comfort to its particular denizen, who is indifferent to the fate of the residents of the adjacent cells. Each of them is the inhabitant of a physical space, with walls and bars, as well as the resident of the walled-in social knowledge of his cell.

The courthouse cannot totally preserve the separation of its several zones; the forbidden knowledge of defendants penetrates the Forbidden City, to which it relates with mockery and parody. It is only a seeming separation, interrupted from time to time by strange and grotesque intrusions from one part of the Hall of Justice to another. Such are the judicial legs that make their sudden appearance in the public space. They have the nature of a will-o'-the-wisp, a fata morgana, an upside-down city at the distant horizon. This phenomenon reveals the uneasiness of the separation between the punitive power and the interpretive power. The problem is both topographical and conceptual. These are parallel worlds, alternate worlds, that are wrestling for control of the same place. The bizarre manifestations that are an integral part of the experience of the courthouse disclose the negligence in the maintenance of separate worlds. The courthouse is a heterotopia, a place where alternative regions intermingle and create spatial strategies of confrontation, interpolation, shifting, overlapping, inversion, assimilation, and absorption.

Michel Foucault (Foucault 1986, 22) describes the heterotopia as a place in which objects are placed and arranged in zones that are so different that it is impossible to find a common ground for all of them. A heterotopia is a locus of crisis; it can juxtapose in a single real place several spaces that are quite different and even incompatible. Foucault mentions cemeteries, hospitals, and psychiatric institutions. The courthouse satisfies Foucault's principles of the heterotopia. Heterotopias are always equipped with gates—a system of opening and closing that isolates them and monitors admission. They are not open to the public; either entry is compulsory—as with a hospital, prison, or barracks; or those who enter must undergo a rite of purification. Heterotopias trouble rest and undermine language. In a heterotopia, objects cannot be assigned a specific name. Syntax is destroyed—not only that which structures sentences, but also the less obvious syntax that allows words and objects to survive alongside or opposite one other.

The irksome incessant reflections of the separate worlds in the Hall of Justice create a perpetual backdrop of hushed and mocking murmurs that subvert legal language, expose it as low, superficial, and clownish. The legal *ratio,* honorable and quite lacking in self-irony and environmental humor, is constantly being penetrated by weird and shameful visions. Because of the truncated mirrors, with their larger-than-life close-up of limbs without a head, these visions have a somewhat pornographic character. In the courtroom, which, like every road junction, is a place of magic and power, judges perform the great judicial act that gives them dominion, without access, over the other tenants of the Hall of Justice—the act of summoning and ejecting. With a single word, with a nod of the head, the gesture of a finger, the prisoner is brought up from the Netherworld into the courtroom; and with the same word and gesture the judge sends him back there. By virtue of the miraculous power produced by their ability to declare someone in contempt of court, judges can issue an order that causes any person in the courtroom—including attorneys and witnesses—to vanish at once into the Netherworld. Judges' power to command a person's presence transcends the courtroom: a subpoena can bring a peaceful resident of any place in the country to that Netherworld.

The Hall of Justice is a huge wheel of Swiss cheese, largely hollow on the inside, crisscrossed by tunnels—a sea of a thousand cavities. Judges, police officers, attorneys, prisoners, witnesses, relatives—all appear from various holes and later vanish into them, in compliance with the noiseless summonses of judges in distant courtrooms. There used to be a system of doors connecting the several worlds, but these have now been hidden and forgotten. Today the passage from the Netherworld to the forbidden districts takes place through the courtrooms. It is far from uncommon, in the middle of a trial, to see a door connecting the courtroom to the holding cells open, after which a police officer and prisoner enter, chained together, rapidly crossing the courtroom on their way to a disembodied judge, their face bearing a foolish expression of hope—for an explanation, for meaning, for a verdict. Cases of illegal penetration or infiltration from one realm to another are rare. All three communities agree to and accept the total separation among the regions. The Forbidden City and the doors to the judges' chambers are guarded only by the court bailiffs, who are unarmed and not visibly powerful in a physical sense. They are very different from the security men who accompany prime ministers or other senior officials. I once asked some of them about attempts to infiltrate the Forbidden City; they could not remember any. All the same, not long ago a disciplinary panel convicted an attorney for entering the chambers of Justice Aharon Barak without permission. The slap on the wrist he received—a fine of several hundred sheqels—shows how uncommon the phenomenon is and thus in no need of strong deterrence.

It is true that attorneys are occasional visitors to all three regions, but their entry visas are limited. Their visits to the Forbidden City are more ceremonial events than a true entrance. From time to time judges invite them into their chambers, but I have never heard of an attorney's being invited to tour the more exotic sites of the Forbidden City, such as the restrooms; in particular, they are never invited to take a short stroll with a judge, engaged in friendly conversation, on the hanging causeway.

Attorney's permits to visit the Netherworld are also limited. Sometimes they pass through the door at the side of the courtroom that leads there, in order to have a short conversation with a client; but this penetration is limited by the unwritten three-stair rule. That is the maximum distance they are allowed to descend; but it is far enough to feel the noisome wind blowing from below. They halt at a point where they can still maintain eye contact with the courtroom. Anyone who goes further, beyond the three stairs, risks never being able to return to the public areas. This is not a rule that is recorded in the lawbooks or regulations, but all obey it. The architecture of the courthouse and the arrangements for entering and leaving it are not protected by guards or demarcated by walls, doors, and corridors. It is an abstract and conventional architecture, only part of which needs to be materialized in concrete or locks. This is the practice encoded in the architecture of the courthouse, like a legal code enshrined in concrete. There is informal communication between the various regions of the Hall of Justice. Passersby on Berkowitz St. may see a man lying on the pavement, not far from the judges' entrance. This is not some down-on-his-luck fellow who has flung himself to the ground to appeal to a judge who has already gone past and entered the building through the small door, but a séance, an attempt to communicate with the Netherworld. Generations of prisoners have passed on the oral tradition that prisoners' voices can be heard through the air shafts that open here. The man lying on the ground places his ear against the grill that covers the air vent. Then he puts his mouth to it and shouts, calling directly to the bird held captive in the bowels of the building.

Judges never penetrate the Netherworld, just as one cannot imagine prisoners' entering the judges' chambers. But it is not so unusual for a judge to suddenly materialize in the public areas, in his full height and substance. These are usually judges of the magistrate's court, or court registrars—judges in potentia, as it were, midway in their metamorphosis from defendant to judge. Judges in the public areas appear in small groups, a sort of judicial commando squad, somewhat tense and nervous, ready for any danger. A judge outside her courtroom is ill at ease; because the judicial magic that can make people vanish is ineffective there, she is compelled, against her will, to tolerate their continued physical existence and monochromatic presence that affects her the same way as it does the regular denizens of the public areas.

No detention cells are as malodorous and humiliating as the holding cells in the courthouse. The prisoners are filthy; the street clothes or house dress they happened to have on when they were arrested is wearing out; buttons are falling off and the stuffing is coming out of the fancy jackets. It is strange to see how quickly almost all the former status symbols fall into tatters. It brings to mind an ethnographer's account of some liminal place where the transition from one social status to another occurs, such as the sites where children enter adulthood through coming-of-age rituals. What takes place in the courthouse is the transition from the former stage of a free human being to the more adult stage of a human being locked up in a community of prisoners. As described by Victor Turner (Turner 1982, 26), the liminal place is dark and concealed, like the sun during an eclipse. It is a place that stands apart from society—a forest, a desert, the outskirts of a village. Life there is cut off from the normal dialogue with society, in a liminal stage, naked and nameless, wallowing on the ground like an animal. The liminal status blurs the contrasts between life and death, between male and female, between those who eat and those who excrete. It is both, at one and the same time. It is a moment when they are dead to their former status but have not yet been reborn in their new one. It is a process of erasure or of leveling, in which all marks of the former status are erased but those of the new status have yet to be registered. Over days of detention in the holding cells of the courthouse, the signs of the free man disappear one by one. The clothes turn into rags; a beard distorts the smooth cheeks of civilian life. It is only when the alteration of clothes to rags is complete and the judge realizes that the detained man has shed all the signs of his former status and is ripe for a new status that he pronounces sentences. The detainee, now a convict, is sent to prison, where he will be shaved, showered, and issued a prisoner's uniform.

The courtroom, which lies outside the walls of the Forbidden City and beyond the River Styx that encircles the Netherworld, is the only possible meet-

ing place for judge and prisoner. During a trial, as during a love affair, the two gradually grow closer. The false barriers drop and the lies are uncovered one after another, as if the two had never inhabited different worlds. The verdict is the culmination of this encounter. At that moment, the defendant faces the judge, stripped of all his secrets; but it is precisely then that the denizen of the Forbidden City is repelled by him, suddenly aware of the tragic gulf between them. And then, in an act the defendant perceives as shameful betrayal, he orders that the man be hidden from view for the duration specified in the sentence. As soon as the verdict has been handed down, the judge withdraws into the Forbidden City. The confused prisoner, still trembling from the intensity of the climax, from the blows of the punishment apparatus, is led to the armored elevator that carries him back to the depths. And the public scatters outside, hurrying to its schemes and criminal conspiracies, its destructive relationships–the raw material of the punishment apparatus.

The Law Library

Law is a place and a text that complement and reflect each other. You cannot separate the place of the law from the law library. In this section I will consider two books–the first is actually a series, with no start or end; the second is ostensibly a single volume, the legal lexicon, but actually an infinite series of mutual reflections.

Every year the Israel Bar Association publishes a new volume in the series of Supreme Court verdicts. These *Collected Verdicts* usually have four parts–some 3,200 pages, 350 verdicts, bound in official blue-green cloth.

The first page of each volume of Collected Verdicts lists the justices of the Supreme Court during that term by seniority. They are its authors, working in the mode of the "chain novel," with each team of three justices writing one episode. On rare occasions, when there are double episodes (known as a rehearing), five or more justices collaborate. The larger number of authors detracts from the story's completeness and plot line, but there can be no doubt that it remains a single plot. The litigants are the changing actors in the series. They retain their names only in the heading that introduces each ruling. In the text of the verdict they are stripped of their former names and recast as "the plaintiff" and "the respondent," "the prosecution" and "the defendant." The other characters who took part in the criminal drama, too, lose their own names and become archetypes–the "victim," whether of murder, rape, or robbery. What we have before us is the primordial couple of prosecutor and defendant, splitting repeatedly, discarding their clothes up and down the courtroom. This is the principle of obsessive repetition that Deleuze and Guattari refer to as the "paranoid series." In their book on Kafka they write:

> The characters in *The Trial* appear as part of a large series that never stops proliferating. Everyone is in fact a functionary or representative of justice (and in *The Castle,* everyone has something to do with the castle), not only the judges, the lawyers, the bailiffs, the policemen, even the accused, but also the women, the little girls, Titorelli the painter, K himself. Furthermore, the large series subdivides into subseries. And each of these subseries has its own sort of unlimited schizophrenic proliferation. Thus Block simultaneously employs six lawyers, and even that's not enough; Titorelli produces a series of completely identical paintings."
> (Deleuze and Guattari, 53)

The schizophrenic power that inheres in the law and is exemplified by the principle of obsessive repetition, unlimited proliferation; the clear feeling that the litigants who people the pages of the *Collected Verdicts* are the incarnations, fragments, the husks of a single warring couple, ancient, Gnostic, the archetypical internal contradiction that is not susceptible to mediation, just as width can never reach a compromise with length: this is precisely what Dickens has his London solicitor in *Bleak House* say:

> We are always appearing, and disappearing, and swearing, and interrogating, and filing, and cross-filing, and arguing, and sealing, and motioning, and referring, and reporting, and revolving about the Lord Chancellor and all his satellites. ... This counsel appear[s] for A, and that solicitor instruct[s] and that counsel appear[s] for B; and so on through the whole alphabet, like the history of the apple pie. And thus, through years and years, and lives and lives, everything goes on, constantly beginning over and over again, and nothing ever ends. And we can't get out of the suit on any terms, for we are made parties to it, and MUST BE parties to it, whether we like it or not. (Dickens 1981)

In his introduction to the novel, J. Hillis Miller wrote that it is no surprise that synecdoche is Dickens' preferred mimetic device. "Each character, scene, or situation stands for the innumerable other examples of a given type" (Miller in Dickens 1981, 11).

These innumerable types, the obsessive repetition of a single conflict, find direct expression in the volumes of *Collected Verdicts* immediately after the names of the justices, in the titles of the verdicts. In keeping with the English tradition, each verdict is named for the opposing parties, separated by the word *versus,* running from "Aloni *versus* the Minister of Justice" through "Putzkov *versus* Pe'er." It is a global conflict: on one side we find Shehadeh Tamimi, Spiegelman, Shantsi, et al.; on the other side Giladi, Chupnik, the Minister of Defense, the State of Israel, et al. The line that divides them expresses an essential rivalry, perpetual conflict, eternal hatred. They pursue one another to the ends of the earth, changing disguises, occupations, identities, gender, and language, but the opposition always remains symmetrical: the *versus* is planted between them like an axe.

The separation of the parties' names by *versus* expresses one overt clash in a series of hidden and endless conflicts. The *versus* that links them in the title of the verdict is a fixed marker of competing relationships and tactics, different lifestyles, and antithetical procedures of daily life. In the phrase "Bakshi *versus* Yardeni," *versus* has the same semantic reality as the litigants' names. It is a third party, with an autonomous existence, not dependent on the two litigants who hold on desperately to its two ends. The compiler of the list of litigants at the start of each volume of *Collected Verdicts* knows this too; right after the list of cases in the normal order they appear a second time, but now with the respondent preceding the appellant: "Chofanier, Jabbar *versus*." The *versus* has jumped from its accustomed place between the two parties and won its own place in the verbal space of the verdict's title.

The verdicts are a window, opened briefly, on the arena of certain practices in daily life, which are generally hidden from view, concealed in the big cities, in the business districts, in the marketplace, in the prisons, in the hospitals, or on the beach at Tel Baruch (a favorite haunt of prostitutes and their clients). These are all activities of daily life that by their very nature are not documented and avoid documenting themselves. They have no PR agents and are not perceived by superficial eyes on the qui vive for objects worthy of artistic representation. In their daily life, the litigants prefer camouflage, flanking maneuvers, and feints over open movement. The parties on the two sides of *versus* are engaged in continuous guerrilla warfare. As noted by Michel de Certeau, the daily processes that are exposed by verdicts—"dwelling, moving about, speaking, reading, shopping, and cooking"—only "seem to correspond to the characteristics of tactical ruses and surprises: clever tricks of the 'weak' within the order established by the 'strong,' an art of putting one over on the adversary on his own turf, hunter's tricks, maneuverable, polymorph mobilities, jubilant, poetic, and warlike discoveries" (Certeau 1988, 40). A verdict in the case of "John Doe v. Richard Roe" is an armed conflict between two systems that organize space and time in different ways, accumulate different material worlds, and juxtapose antithetical tastes.

By the time a case reaches the Supreme Court it has already been plucked naked, its facts reduced to archetypes. If the appellant is holy, the respondent is impure; if the petitioner is tall, the respondent is a dwarf; if the defendant is bold, the accuser is a coward; if the applicant is a master, the respondent is a slave. The *versus* separates them like a curse they are trying to escape. "Hi there!" calls Tchaikovsky to Kaplan from the other side of the *versus*. "We are brothers, almost the same, twins, really. Let's find a compromise." They try to draw closer to each other, but then the curse complicates them in a murder, a property dispute, drug smuggling. There is no way to get past the *versus*. They try to tunnel through it, each digging from his own side, but they never meet up. Each exits at the far end and finds the *versus* still between them. They are like Punch and Judy, each trying to reach out and grab his reflection's neck from the other side. In one episode they both live in a condominium—he upstairs, she below. He wants to build on the roof; she wants to hang her laundry there. In the next episode he is an attorney and she is his client; he is a man and she is a woman; she wants a child and he wants to be free. Punch struck Judy on the head with a blunt instrument, but this time he hit her too hard and crushed her skull, so Punch is alive and Judy is dead. In the next episode, a new team of writers brings Judy back to life. This time she is young and he is old; she convinced him that he had stomach cancer, so he committed suicide and left her everything in his will. These are all different stories found in a single volume of *Collected Verdicts,* but there is no way to avoid identifying the same characters in all of them.

Until they were exposed in the verdicts, the litigants lived under the public radar, furious and

angry with each other, unrestrained, wild in their isolation, possessors of a secret history, warped and subversive—until, as if by spontaneous generation from slime, they were reborn as public litigants, complete in every detail, from the nose that turns white with anger to the tiny mouth that is always curling down in humiliation. They become the indentured servants of the legal skirmish into which they were sucked, with no way to escape. They drag it from the Magistrate's Court to the Supreme Court, in a journey that takes eight or ten years. Until one fine morning they trudge up the stairs in the Supreme Court building in Jerusalem, like two beetles transporting a bit of trash several times their own size. They enter the courtroom—usually Number 3, which is the smallest—aggravated, disheveled, exhausted. They say, submissively, that we, "Avneri *versus* Shapira," request a ruling. Please, Your Honors, remove this huge particle that is crushing us into dust and to whose careful conveyance we have devoted our lives until now.

Our hope of finding that the verdict is an ethical treatment of desire and its limits, of power and its restraint, is disappointed. Only rarely do we find evil incarnate in the dock. The penal code stipulates that the motive for a crime is not part of the crime and consequently is not relevant in the courtroom. The deed whose history is unfolded during the trial begins later, when the passion took material form as a criminal offense; and the story of the deed reaches its conclusion when the signs that the criminal left strewn all along the way, tiny confessions of blood, sperm, and urine, lead to him. But before passion can be realized as a criminal offense, there is ample time for it to be watered down and weakened. So much effort is needed for a crime—the planning, the complex conspiracy that accompanies every criminal act like a black hood, keeping tabs on one's accomplices—who are always lazy, garrulous, careless. All these dull the edge of the felony; and the trial, instead of dealing with the passion that breaks bones, deals with evasions and arrests, and mainly with the failure to advance the evil intention from potential to actual.

In most verdicts, only about twenty percent of the text is new material; the rest consists of quotations—a recycling of previous judgments, a cannibalization of older texts. Judges are constantly reusing well-known episodes from years past; it would be quite injudicious for a judge to take a single legal step without a quotation to support him. Without one, he feels as if he is buck naked, exposed to the elements, disgraceful and embarrassing in his presumption to distinguish truth from falsehood. Judges cite previous rulings of others, and frequently their own; weak judges cite strong judges with a sort of Oedipal lust. In some verdicts, one has the sense that it was recycling itself even before the text was printed, its end citing its beginning, like a snake swallowing its own tail. With one last effort the text would self-destruct, vanishing into the void with a soft hiss. Judges quote, because the daily lives of litigants, with their pointless and meaningless disputes, mad and mendacious, trigger horror. Daily life as pictured in the legal process is, as Stanley Cavell observes of Wittgenstein, an arena of illusion, trance, and loss (Cavell 1989). Wittgenstein's proposition in the *Philosophical Inquiries*: "Make the following experiment: *say* 'It's cold here' and *mean* 'It's warm here' Can you do it?—And what are you doing as you do it? And is there only one way of doing it?"(Wittgenstein 1981, §510)—is a daily experience for every set of litigants. Against the real world, a quotation serves as a crutch, reliance on a judge who preceded you; and later the feeling of a warm hand on your own shoulder, when someone else quotes you. Judges are like the blind men in the painting by Pieter Bruegel, each relying on the next one's blindness, quoting themselves to death. Would you trust them to decide between good and evil?

Citations are also the never-ending dialogue that judges conduct among themselves and with their judicial forebears who have already gone to their final reward—that is, who have retired from the bench and reacquired their flesh-and-blood substance. This dialogue by citation plays a major role in sustaining judges' subjective reality, just as conversation helps preserve the many segments of social reality. In the words of Luckmann and Berger, "The most important vehicle of reality-maintenance is conversation. One may view the individual's everyday life in terms of the working away of a conversational apparatus that ongoingly maintains, modifies and reconstructs his subjective reality" (Berger and Luckmann 1966, 172). Conversation serves to keep the self-understood up-to-date; as the dictum of rabbinic law (frequently cited by Israeli judges) has it, "The self-evident requires no proof." Aspects of reality that are not the topic of ongoing dialogue gradually fade away until they vanish from sight and wink out of existence. In order to play these cognitive and social roles the conversation must be unending. Any disruption of the dialogue leads at once to an uncomfortable sense of cracks in the self-evident elements of reality. Judges' perpetual need to quote includes hackneyed texts that have been cited dozens of times in the past. Stale passages that in no way strengthen the argument or add to its persuasive force are inserted within quota-

tion marks. So intense is the urge to quote, so great is the fear that truncating a passage would expose the judicial reality as random and arbitrary, terrifying in its material poverty, that judges frequently quote themselves, morphing into divinities with two bodies, one earthly and historical, the other abstract and hovering constantly above them. It is a glorious union of denotator and denotatum. The citation of judicial predecessors also performs the ritual of calling up the dead: the ghosts of the fathers of the judicial tribe are summoned to counsel their descendants in times of crisis and hardship. Alongside the normal quotation, which preserves the discourse that encompasses all members of the judicial tribe, there is also deviant citationism, manifested in misquotations of earlier authorities. This is a form of cannibalism in which the leaders are consumed and incorporated into the eaters' bodies. The chain of judicial rulings is a noisy and nonstop banquet, at which judges eat, chew, gnaw, nibble on, and spit out other judges, and sometimes even themselves. Readers of *Collected Verdicts* discover that the plots of the rulings it contains sink under the weight of facts that are piled high and wide. A verdict swells, like the corpse in the apartment of the couple in the play by Ionesco, and will soon fill the entire world. Every handful of sand in the clear plastic bag that the Criminal Identification Unit has brought to the courtroom (State's Exhibit 1) is an entire world: for example, traces of the Siberian steppes trapped in the soles of the shoes of a new immigrant from the Soviet Union, who met a woman at an evening course and used a pressure-cooker cover to kill her ("Kogan v. the State of Israel"). Reflecting on the Italian novelist, Carlo Emilio Gadda, Italo Calvino writes about multiplicity: "... the least thing is seen as the center of a network of relationships that the writer [or judge] cannot restrain himself from following, multiplying the details to that his description and digressions become infinite. Whatever the starting point, the matter in hand spreads out and out, encompassing every vaster horizons, and if it were permitted to go on further and further in every direction, it would end by embracing the entire universe" (Calvino 1988, 107). A tremor passes down the chain of judges. "That's terrible," they whisper, and tighten their grip on the bowed back of the blind man ahead of them in line.

In addition to citations, another device for presenting subjective reality as self-evident is the cliché. If quotations are the firmament of judicial discourse, the cliché is its ground. Clichés are well hidden in verdicts, dressed up as substantiation, probability, deduction. To detect its character and qualities we must extricate it from the verdict and set it on its own feet. This is done on the margins of the law, in the definitions section of the judicial lexicon and my personal inventory of self-evident known facts that do not require proof.

Laws and regulations generally include a section of definitions or glosses, a sort of short dictionary of the terms that appear in that item of legislation. Someone actually went to the trouble of compiling, alphabetizing, and publishing them (*Lexicon of Legal Terms in Israel,* edited by Amnon Lorch and Ami Folman). This is a vast collection of definitions, like a phrasebook for tourists in a foreign country, and an amusing read. Some definitions resemble a scorpion's tail that curls around and stings the word being defined to death. The law has various means to effect the self-destruction of a good word. In one case it may expand the sense endlessly and obfuscate everything the word formerly denoted; for example, when the right side of a motor vehicle is defined as "including the left side" (left side: including the right side). In other cases the murderous deed is performed by restricting the sense repeatedly until the word is strangled to death.

Travelers in a spaceship to the dead planet "Earth" at the far end of the galaxy might find this lexicon an interesting diversion. The crew, including a professor of artificial languages and a poet, discover the lexicon on "Earth" and use it as the basis for reconstructing the creatures who once inhabited this scorched globe: what they ate, how they propagated, what made them laugh. First they look through the lexicon for definitions of matters of life and death. It turns out that these creatures did not have independent energy. "Live," the explorers read, refers to what is "connected to an external source of electrical voltage"; "dead" is what is "disconnected from all voltage sources and has no electrical charge." As long as they were plugged in, the inhabitants of "Earth" were frantic and insecure. The days grew longer and shorter in arbitrary fashion. The lexicon defines "day" as three different time intervals. "Night" varies according to the natives' age and sex: a toddler's night is twelve hours, a child's ten, a teenager's six. A woman's long night began at 6:30 in the evening and ran until 6:30 the next morning. Evidently because of the different lengths of men's and women's nights, her life passed more quickly and she grew old before the man, as indicated by the definition of "elderly couple": "A couple in which the man has reached age 65 and the woman age 60." How wasteful, self-centered, and voracious was that race, which defined a fish as "an animal that lives in the water whose flesh serves for

human consumption." "Human beings," who evidently dominated the planet, are defined, inter alia, as those who tend cattle "in order to slaughter them or purvey their flesh to consumers." In another place, in a different statute, "man" is defined as a "market-stall owner": does this mean that those who had no stall were eaten by the stall-owners? These human beings, whom our crew are no longer so sorry to find extinct, could see no further than the end of their noses. Air, which the spacecraft's sensors have found to be a mixture of nitrogen and oxygen a hundred kilometers deep, was defined by the stall-owners as that "portion of the atmosphere with which humans come into contact," while the blue water that covers two-thirds of the planet was "the coastal waters of Israel": that and no more?

The legal epistemologist can find an astonishing collection of clichés, prejudices, and asininities in the lexicon—the building blocks from which judges construct reality. It seems appropriate to supplement the lexicon with an anthology of what the courts have designated "self-evident facts that do not require proof." As an amateur epistemologist I have amassed a respectable collection of these, all of them genuine: "Summer is hot and winter is cold"; "streets meet and form intersections"; "items sent by mail arrive"; "waiters replace the labels of cheap champagne with the labels of expensive champagne"; "people who drink alcoholic beverages may totter when they walk but remain perfectly lucid." And, to cap them all: "A person who falls suddenly sticks his arms out in front of him and does not wrap them around his body." Taken in combination, the lexicon of legal terms and anthology of self-evident facts that do not require proof constitute an absurd dictionary of conventional facts, of the sort imagined by Flaubert and whose composition he assigned to Bouvard and Pécuchet, the protagonists of his last book. Their definition of an instrument: "If used to commit a crime, it is blunt, unless it is sharp." The legal lexicon, by contrast, defines a work tool as "a firearm of a type so declared by the Interior Minister."

Metaphor and Metonymy in the Law
Legal discourse develops chiefly along the axis of metonymy. However, by chance or intentionally, as a coincidence or as a message emitted from deep layers as an icon or symbol, we may be astonished to see it as a metaphoric mode of expression. In the word of Roman Jakobson, "the development of a discourse may take place along two different semantic lines: one topic may lead to another either through their similarity or through their contiguity. The metaphoric way would be the most appropriate term for the first case and the metonymic way for the second, since they find their most condensed expression in metaphor and metonymy respectively. [...] A competition between both devices, metonymic and metaphoric, is manifest in any symbolic process, be it intrapersonal or social" (Jakobson 1990, 129, 132).

In the law, metonymy first asserts its primacy in the stage of the police investigation. As noted by the nineteenth-century legal scholar, James Stephen (Stephen 1964), society is fortunate that criminals, and especially murderers, cannot avoid leaving behind a trail of signs that ultimately lead to their identification. The rhetorical device of the criminal investigation is metonymy—reading the signs and replacing a footprint with a foot, dried semen with a penis. The indications are carried by bodily fluids: urine, blood, semen, tears. Emptying the bladder is a confession. The yellowish liquid in the test tube of the forensic laboratory contains the drugs we took, the alcohol we drank, the tranquilizers we gulped down to get through the difficult days; semen is the secret and terrible historian that records, quietly and behind our back, the fact that we engage in homosexual intercourse or are not picky in our choice of our partners. "You will soon die an agonizing death," chirp the tiny spermatozoa in chorus. The vital fluids we carry inside us are a fifth column, a nest of spies who will betray us to the police at the first opportunity. Forensic science recruits our own body and turns it into an undercover detective. In a trial, such as a murder trial, the similar and unique chase each other. All the exhibits submitted by the prosecution and the defense refer to one another. The tire marks are a linear image, a hasty impression left behind by the murderer's car. The hair in the sink of the bathroom of the hotel where the victim spent the previous night belongs to him; and by chance it was not flushed down the drain or wiped away by the chambermaid. A chilling picture emerges, a flat and one-dimensional universe, centered on the corpse that was carted away from the site and replaced by a chalk outline, resembling an elongated sausage. A murder trial is an animation of the signs that presaged the evil. Every object collected and every item submitted in evidence refer to the others and to the grave, violent, and furtive scene from which they were taken. It is a world rather like that described by Nabokov in his short story "Symbols and Signs," in which parents visit their son in a psychiatric hospital. He is "incurably deranged in his mind": "man-made objects were to him either hives of evil, vibrant with a malignant activity that he

alone could perceive, or gross comforts for which no use could be found in his abstract world" (Nabokov 1948).

Not long ago, the Supreme Court ruled that bite marks (in this case they were made by a set of false teeth) are sufficiently distinctive and unique to provide absolute identification of their owner. Henceforth, biting constitutes its own semantic field. This is a festive event, like the birthday of the sonata. Justice Kedmi (Criminal Appeal 517/86) has equipped us with the poetic aspects of a bite: "the pattern"–that is, the form of the bite; "the domain of the mark," which is the impression the tooth leaves on the skin; and the "domain of the curve," or the shape of the jaw. The metonymic world of legal evidence, which references and quotes, is a supreme example of the legal discourse, which also references and quotes. The relationship between the tooth mark and the tooth is also one of quotation and reference. As noted, the main metonymic axis of the law creates a world with no depth, a place where a chalk outline replaces the corpse and blocks off meanings that might emerge from the depths of the narrative. The distinction between deep narrative and surface narrative, according to Greimas, is that between meanings revealed on the outside of the narrative and those that are deep and paradigmatic, outside time, concealed in its depths (Greimas 1971). As Hayden White noted (White 1978), scanning the legal text against the metonymic grain and along the metaphoric grain transforms it into a mediator between the events it reports and pre-generic literary structures. These structures yield fundamental meaning by assigning new events to primordial cultural paradigms. This mediation is accomplished by means of the icon (in Peirce's sense), the symbol, and the metaphor.

When we read the stories told by the verdicts, we often have a vague sense that at some hidden level they share common narrative paradigms. Minor details recur stubbornly; characters have symbolic names; the court mentions objects or physical traits that are quite irrelevant to the plot of the verdict, giving them the ambiguous status of symbol or icon. A vague sense emerges that the verdicts are held up by a hidden scaffolding of primary symbolic plots.

The "Boy Who Cried Wolf" is a frame tale, a general formula for a diverse and branching family of events. On the surface, the story is the antithesis of the carnival, preferring the villagers' grimness and gravity over the clowning shepherd who keeps crying "wolf, wolf" and pretends to be terrified. There is also the compulsive repetition of the cry "wolf," which exposes the joke and parody as a repetitive obsession and imitation of the real and lethal wolf. This is not the place to look closely at the deep plot of the wolf, the shepherd boy, and the villagers, with their interdependence, asynchrony, and lack of a common language. But how threatening and terrifying it is when wolf and shepherd appear in a ruling by the Supreme Court–Criminal Appeal 26/89, "Zev v. The State of Israel" (published in Collected Verdicts xliii 4 634). [Zev is the Hebrew word for "wolf" in addition to a common name.] The appellant, Zev, a shepherd (and we cannot avoid a thrill when we learn that Zev-Wolf, too, tends sheep) who lives in Shilo (on the West Bank) saw Arab shepherds congregating, in the court's words, "in worrisome proximity to the settlement, including a playground full of toddlers" (the role-switch between wolf and shepherds will inform the plot till its climax). Zev-Wolf decided to chase the Arab shepherds away. "First," write the justices, "he yelled at them *ruhu min hon*" ("get away from here" in Arabic). After that, he began firing volleys in the air, while advancing towards them. And when this failed to send them packing, he (the "wolf") decided to up the ante by shooting in a different fashion, aiming at the ground halfway between himself and the shepherds, who were 40 to 50 meters away. The appellant (the "wolf") lowered his rifle to his hip and from this position fired a single volley in a short arc of an imaginary circle with him at the centre. The shots killed one of the shepherds, Goda Abdallah Awwad, and wounded another, Rizek Abu Na'im. One of the sheep was killed as well. It should also be noted that the shepherd Rizek testified that "at the height of the incident he shouted at the appellant (whom he had known for some time), 'Israel, Israel [which happens to be the wolf's first name], don't shoot–it's me, Rizek.'" This narrative has such turbulent depths: a wolf, Israel, shepherds tossed on the water like fearsome sea monsters that inspire nightmares. The names Zev and Israel, the shepherds, the death of the shepherd and the death of the lamb at the hands of the "wolf" are a string of coincidences, what Jung calls "synchronizations" (Jung 1985). They are reflections, series, doublets, multiplicities that cannot be explained by the principles of cause and effect, but by some other acausal principle, which assumes that in addition to cause and effect there is an independent force at work in nature, the force of reflection.

I can imagine a legal doctrine in which people's names are held to be relevant circumstantial evidence for determining guilt or innocence. According to Derrida, a person's name lies outside the bounds of

discourse, it is both present and absent; it is neither assimilated nor absorbed. Persons' names are untamed and arbitrary elements, associated with a dimension that obeys metalinguistic and genealogical laws. This is a level that legal discourse cannot control, a choice made without supervision. Legal discourse is troubled by these feral names, small and overcrowded islands of a family discourse that is hostile to the legal discourse. This is why family lacunae swarm in the depths of verdicts. Verdicts make extremely sparse use of person's names, which they replace by "the victim," "the appellant," "the accused," "the prosecution," "the respondent."

A Page Torn from *Collected Verdicts*
A page torn from the full judgment, ripped out of a volume of *Collected Verdicts* and removed from the law library, is left defenseless, with no antibodies, plagued by allergies, a victim of immune-system failure. Outside the legal bubble, it is exposed to diseases, petty annoyances, bites, and rips. It is a page torn from "Zev *v.* The State of Israel," discussed in the previous section. This is an unquiet text, beset by severe acrophobia at the sight of the metaphoric abyss that gapes below it. The legal language advances cautiously on the thin membrane of surface tension, in tiny steps. The slightest downward pressure of the leg would crack this surface and eliminate the line that divides speech from the subjects that howl below it, confound the judges' portal with that of the criminals.

Deleuze compared Lewis Carroll's surface language with Antonin Artaud's deep language:

> Alice progressively conquers surfaces. She rises or returns to the surface. She creates surfaces. Movements of penetration and burying give way to light lateral movements of sliding; the animals of the depths become figure on cards without thickness. All the more reason for *Through the Looking-Glass* to invest the surface of a mirror, to institute a game of chess. Pure events escape from states of affairs. We no longer penetrate in depth but through an act of sliding pass through the looking-glass, turning everything the other way round like a left-hander. [...] But the world of depths still rumbles under the surface, and threatens to break through it. Even unfolded and laid out flat, the monsters still haunt us. (Deleuze 1997)

Similarly, legal discourse is possible only when there is a separation between language and body. This need to stifle the body's squalling is one of the secrets of the judges' vanishing act. Compared to Lewis Carroll's language in *Alice in Wonderland,* that of the schizophrenic Artaud is depth without surface. Objects are filters, and when the surface is pierced, words lose their meaning: "The moment that the pinned-down word loses its sense, it bursts into pieces; it is decomposed into syllables, letters, and above all into consonants which act directly on the body, penetrating and bruising it" (Deleuze 1980).

The changes I marked on the page are quite random. When the surface tension is broken, everything is possible. But they also offer a stolen glance at the Supreme Court's technique of story and plot, and especially the motif of children versus shepherds, who function here as the wolves of the fable. Even though the children are not significant and their presence in the plot is accidental—in the final analysis, the shepherds really were shepherds and not wolves—they make several appearances on the first two pages of the verdict: Ms. Mansur, who first saw the Arab shepherds in the wolf's skin at a distance of only twenty-five meters from her house and five meters from the settlement's perimeter road, "thought it appropriate to hustle the children into her house." Whereas the appellant (Israel Zev-Wolf) saw the shepherds "in worrisome proximity to the settlement, including the playground full of toddlers." Which explains the graffito scrawled across the page of the verdict: "Children mean health."

Translated from the Hebrew by Lenn J. Schramm.
*Originally published in *Theory and Criticism* (*Teoria U'vikkoret*), Van Leer Jerusalem Institute, 1991

Bibliography

Berger, Peter L., and Thomas Luckmann, 1966. *The Social Construction of Reality.* London: Penguin Books.

Calvino, Italo, 1988. *Six Memos for the Next Millennium: The Charles Eliot Norton Lectures, 1985–86.* Cambridge MA: Harvard University Press.

Cavell, Stanley, 1989. *This New Yet Unapproachable America.* Albuquerque, NM: Living Batch Press.

Certeau, Michel de, 1988. *The Practice of Everyday Life.* Berkeley and Los Angeles: University of California Press.

Cover, Robert M. 1986-. "Violence and the Word," *Yale Law Journal* 95.

Deleuze, Gilles, 1980. "The Schizophrenic and Language: Surface and Depth in Lewis Carroll and Anton in Artaud," in Josué V. Harari, ed., *Textual Strategies: Perspectives in Post-Structuralist Criticism.* London: Methuen.

–––, 1997. "Lewis Carroll," in *Essays Critical and Clinical.* Translated by Daniel W. Smith and Michael A. Greco. Minneapolis: University of Minnesota Press

Deleuze, Gilles, and Felix Guattari, 1986. *Kafka: Toward a Minor Literature (Theory and History of Literature,* vol. 30). Minneapolis: University of Minnesota Press.

Dickens, Charles, 1981. *Bleak House.* Introduction by J. Hillis Miller. London: Penguin Books.

Flaubert, Gustave, 1976. *Bouvard and Pécuchet.* London: Penguin Books.

Foucault, Michel, 1980. *The Order of Things.* London: Tavistock Publications.

–––, 1986. "Of Other Spaces," *Diacritics,* Spring.

Foucault, Michel, and Maurice Blanchot, 1987. *Foucault-Blanchot.* New York: Zone Books.

Gabel, Peter, 1989. "Law and the Denial of Desire." *Tikkun* 4(2).

Geertz, Clifford, 1983. *Local Knowledge: Further Essays in Interpretive Anthropology.* New York: Basic Books.

Greimas, A. J., 1971. "Narrative Grammar: Units and Levels." *MLN* 86(6).

Jakobson Roman, 1990. "Two Aspects of Language and Two Types of Aphasic Disturbances," in *On Language.* Cambridge MA: Harvard University Press, 1990

Jung, C. G., 1985. *Synchronicity: An Acausal Connecting Principle.* London: Ark Paperbacks.

Nabokov, Vladimir, 1948. "Sizes and Symbols." *The New Yorker,* May 14.

Noonan, John T. Jr., 1977. *Persons and Masks of the Law: Cardozo, Holmes, Jefferson, and Wythe as Makers of the Masks.* New York: Farrar, Straus and Giroux.

Scarry, Elaine, 1981. *The Body in Pain.* New York and Oxford: Oxford University Press

Stephen, James F., 1964. *A History of the Criminal Law of England.* 3 vols. New York: B. Franklin.

Turner, Victor, 1982. *From Ritual to Theatre.* New York: Farrar, Straus and Giroux.

White, Hayden, 1978. *Tropics of Discourse, Essays in Cultural Criticism.* Baltimore: The Johns Hopkins University Press.

Wittgenstein, Ludwig, 1981. *Philosophical Investigations.* Oxford: Basil Blackwell.

Avigdor Feldman *(Tel Aviv) is a renowned human rights lawyer. Feldman is founder of the Litigation Center for the Association for Civil Rights in Israel (ACRI), as well as a founding member of the Israeli Information Center for Human Rights in the Occupied Territories (B'Tselem).*

Imprint
Issue 28

Publisher
Dorothee Richter

Co-Publisher
Michael Birchall

Guest Editor
Avi Feldman

Contributors
Hila Cohen-Schneiderman, Avigdor Feldman,
Avi Feldman, Lawrence Abu Hamdan,
Michal Heiman, Sabine Mueller-Mall, Milo Rau,
Jonas Staal

Proofreading
Stephanie Carwin

Web Design and Graphic Design Concept
Ronald Kolb, Biotop 3000

Graphic Design Issue 28
Ronald Kolb, Biotop 3000

Supported By
Supported by the Postgraduate Programme
in Curating (www.curating.org)
Institute for Cultural Studies in the Arts (ICS),
Department of Cultural Analysis
Zurich University of the Arts (ZHdK)